LOVE

IN THE WORDS
AND LIFE OF JESUS

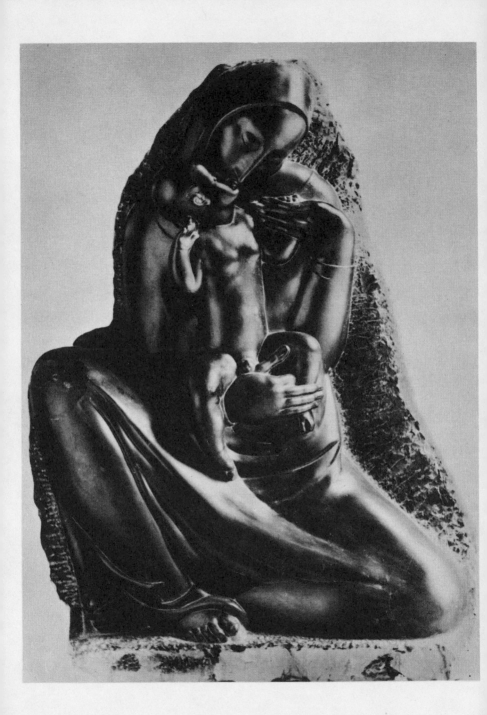

LOVE

IN THE WORDS AND LIFE OF JESUS

By the Editors of Country Beautiful

Illustrated with

the Art of Ivan Meštrović

Published by

Country Beautiful Corporation

Waukesha, Wisconsin

The publishers are grateful to Oxford University Press and Cambridge University Press for permission to use the Biblical texts in this book.

From the NEW ENGLISH BIBLE. Copyright © the Delegates of the Oxford University Press and the Syndics of the Cambridge University Press 1961, 1970. Reprinted by permission.

COUNTRY BEAUTIFUL: *Publisher and Editorial Director:* Michael P. Dineen; *Executive Editor:* Robert L. Polley; *Senior Editors:* Kenneth L. Schmitz, James H. Robb; *Art Director:* Buford Nixon; *Associate Editors:* D'Arlyn Marks, John M. Nuhn; *Contributing Editor:* Denise Wegner; *Editorial Assistants:* Kay Kundinger, Nancy Backes; *Production Manager:* Donna Griesemer; *Administration:* Brett E. Gries; *Administrative Secretary:* Kathleen M. Stoner; *Staff:* Bruce L. Schneider.

Country Beautiful is a wholly owned subsidiary of Flick-Reedy Corporation: *President:* Frank Flick; *Vice President and General Manager:* Michael P. Dineen; *Treasurer and Secretary:* August Caamano.

CONTENTS

On Acceptance 10

On Expecting a Child 11

On Good News 12

On a Pair of Turtle Doves 15

On Obedience 18

On the Prophecy Fulfilled 22

On Being Gentle 24

On Being Generous 26

On Loving Your Enemy 27

On Making Peace with Your Brother 28

On Showing Off 30

On Fasting 32

On Judging Others 33

On Worrying 34

On Never Being Thirsty 37

On the Difficulty of Being Rich 39

On Mary Magdalen and Being
Forgiven 41

On Giving and Repaying 44

On Persistence 45

On Being Simple and Believing 46

On Being Strong 48

On Having a Party for the Poor 49

On Showing Kindness 50

On Being Honest and Genuine 53

On the Kingdom of Heaven 54

On Taking the Last Place 55

On Coming Back to Life 56

On Serving 59

On Asking for the Head of John
The Baptist 61

On the Love of Jesus for John
The Baptist 63

On the Love of Money 64

On Being Callous and Indifferent
to the Poor and Sick 65

On Mercy, Not Sacrifice 67
On Forgiving from Your Heart 69
On Forgiving Seventy Times Seven 71
On Marriage 73
On Children 76
On Rejoicing Over One Sinner
 Who Repents 77
On Being Hypocritical 79
On Coming from the Heart 80
On Being True to Oneself 82
On Throwing the First Stone 85
On Feeding the Hungry
 and Welcoming Strangers 87
On Being a Good Shepherd 91
On the Washing of Feet 92
On Humbling Oneself 93
On Jesus Weeping 94
On Comforting Jesus 97
On the Two Great Commandments 99
On the Seed Falling on Good Soil 100
On Having Faith 102
On the Gift of Peace 104
On the Farewell Prayer of Jesus 107
On the Breaking of Bread 112
On the Suffering in Gethsemane
 and the Betrayal 117
On the Silence of Jesus 121
On His Humiliation, Crucifixion
 and Death 122
On the Resurrection 129
On His Meeting Mary Magdalen
 and the Disciples 131
On His Giving Them the Holy Spirit 132
On Having Breakfast with Jesus 134
On Asking Peter "Do You Love Me?" 137
Ivan Meštrović —
 A Biographical Note 141

INTRODUCTION

St. John tells us that God is love. The true meaning of love is deeply manifested in the life and sayings of Jesus. The manner of His birth, His actions, His words—all have a warm loving expression and a profound sense of regard for the dignity and welfare of each individual person. Artists and writers and musicians through the centuries have attempted to capture and interpret Christ's message. In this book, we present in a rather simple way some of His life and some of His words. In these selections, there is presented the simplicity of Mary, the shepherds, the manger, and Joseph; and the loving concern Jesus had for the poor and the weak; His worry about the rich and His anger with those who are dishonest with themselves and with others.

Jesus gave two commands: love of God and love of neighbor. The poor like the widow, the sick like Lazarus, the sinner like Magdalen, the rich man like Zacchaeus — all these Jesus Himself loved and told His followers that: "If there is this love among you, then all will know that you are my disciples." And further, in the words of St. John, "If a man says, 'I love God', while hating his brother, he is a liar. If he does not love the brother whom he has seen, it cannot be that he loves God whom he has not seen."

There is the giving of Himself at the last supper — "This is My body." This is an act of friendship and love that is not easily understood except in the light of His own desire to remain with those who live the spirit of His message. Finally, He manifests the preciousness of life and love in an inverse way. He is humiliated and crucified and accepts these acts of human destruction on His own person as a sacrificial atonement for all the unloving acts of man to man and man to God.

Those who read the selections in this book we think will discover the new "way of life" He came to announce. His life and words are simple and profound, challenging and difficult, warm and beautiful, for they speak of love.

MICHAEL P. DINEEN

Then the angel said to her,
'Do not be afraid, Mary . . .'
— LUKE 1

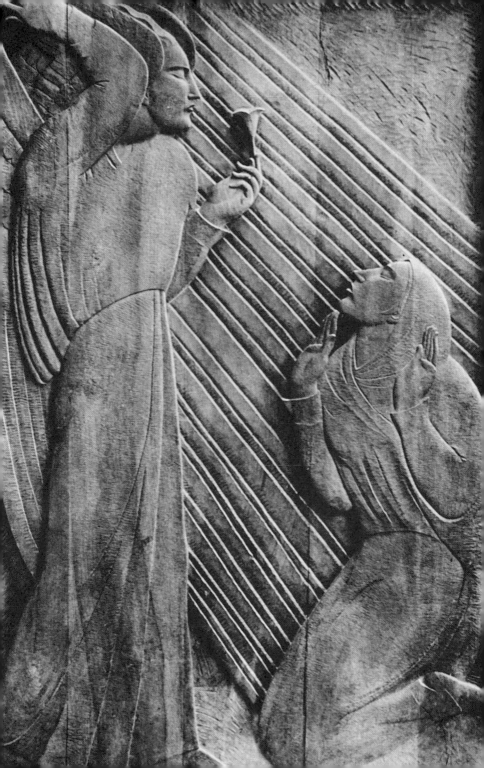

The angel Gabriel was sent from God to a town in Galilee called Nazareth, with a message for a girl betrothed to a man named Joseph, a descendant of David; the girl's name was Mary.

The angel went in and said to her, 'Greetings, most favoured one!

The Lord is with you.' ...

Then the angel said to her, 'Do not be afraid, Mary, for God has been gracious to you; *you shall conceive and bear a son,* and you shall give him the name Jesus.

He will be great; he will bear the title "Son of the Most High"; the Lord God will give him the throne of his ancestor David, and he will be king over Israel for ever; his reign shall never end.'

'How can this be?' said Mary; 'I am still a virgin.'

The angel answered, 'The Holy Spirit will come upon you, and the power of the Most High will overshadow you; and for that reason the holy child to be born will be called "Son of God".' ...

'Here am I,' said Mary; 'I am the Lord's servant; as you have spoken, so be it.'

— LUKE 1

In those days a decree was issued by the Emperor Augustus for a registration to be made throughout the Roman world.

This was the first registration of its kind; it took place when Quirinius was governor of Syria.

For this purpose everyone made his way to his own town; and so Joseph went up to Judaea from the town of Nazareth in Galilee, to register at the city of David, called Bethlehem, because he was of the house of David by descent; and with him went Mary who was betrothed to him.

She was expecting a child, and while they were there the time came for her baby to be born, and she gave birth to a son, her first-born.

She wrapped him in his swaddling clothes, and laid him in a manger, because there was no room for them to lodge in the house.

—LUKE 2

Now in this same district there were shepherds out in the fields, keeping watch through the night over their flock, when suddenly there stood before them an angel of the Lord, and the splendour of the Lord shone round them.

They were terror-stricken, but the angel said, 'Do not be afraid; I have *good news for you*: there is great joy coming to the whole people.

Today in the city of David a deliverer has been born to you — the Messiah, the Lord.

And this is your sign: you will find a baby lying wrapped in his swaddling clothes, in a manger.'

All at once there was with the angel a great company of the heavenly host, singing the praises of God:

'Glory to God in highest heaven,
and on earth his peace for men on whom his favour rests.'

After the angels had left them and gone into heaven the shepherds said to one

another, 'Come, we must go straight to Bethlehem and see this thing that has happened, which the Lord has made known to us.'

So they went with all speed and found their way to Mary and Joseph; and the baby was *lying in the manger*.

When they saw him, they recounted what they had been told about this child; and all who heard were astonished at what the shepherds said.

But Mary treasured up all these things and pondered over them.

Meanwhile the shepherds returned glorifying and praising God for what they had heard and seen; it had all happened as they had been told.

—LUKE 2

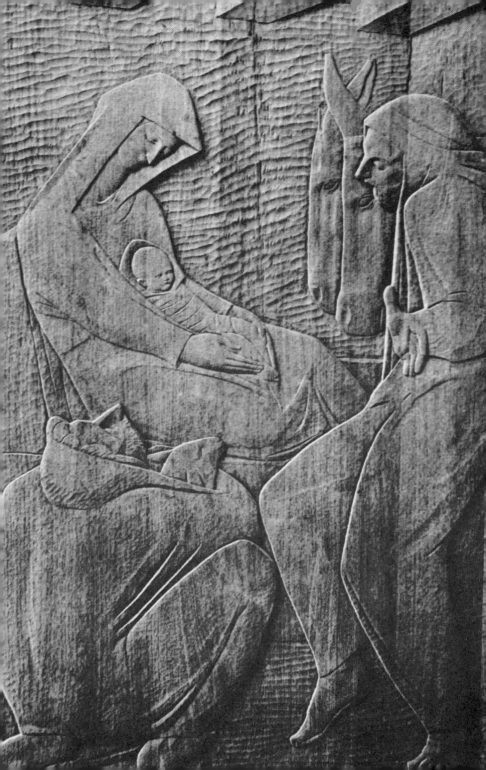

Eight days later the time came to circumcise him, and he was given the name Jesus, the name given by the angel before he was conceived.

Then, after their purification had been completed in accordance with the Law of Moses, they brought him up to Jerusalem to present him to the Lord (as prescribed in the law of the Lord: 'Every first-born male shall be deemed to belong to the Lord'), and also to make the offering as stated in the law: *A pair of turtle doves or two young pigeons.*'

There was at that time in Jerusalem a man called Simeon.

This man was upright and devout, one who watched and waited for the restoration of Israel, and the Holy Spirit was upon him.

It had been disclosed to him by the Holy Spirit that he would not see death until he had seen the Lord's Messiah.

'*And this is your sign: you will find a baby lying wrapped in his swaddling clothes, in a manger.*'

— LUKE 2

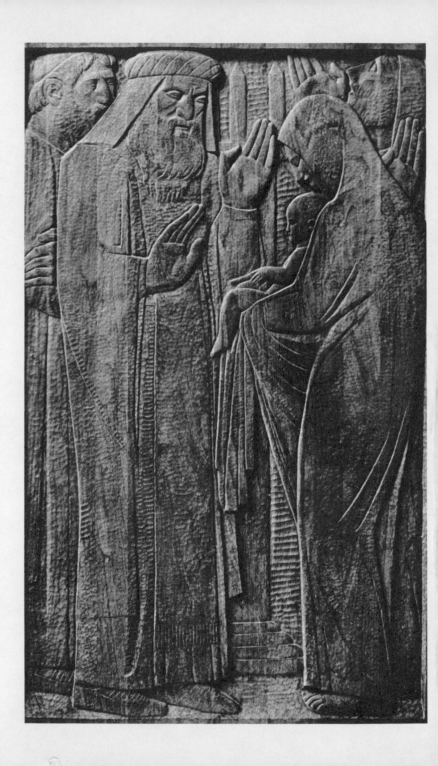

Guided by the Spirit he came into the temple; and when the parents brought in the child Jesus to do for him what was customary under the Law, he took him in his arms, praised God, and said:

'This day, Master, thou givest thy
　　servant his discharge in peace;
　　　　now thy promise is fulfilled.
For I have seen with my own eyes
　　the deliverance which thou hast made
　　ready in full view of all the nations:
　　a light that will be a revelation to the
　　heathen,
　　　　and glory to thy people Israel.'

.

When they had done everything prescribed in the law of the Lord, they returned to Galilee to their own town of Nazareth.

The child grew big and strong and full of wisdom; and God's favour was upon him.

—LUKE 2

*Simeon blessed them and said to Mary his mother,
'This child is destined to be a sign
which men reject; and you too shall be
pierced to the heart.'*
— LUKE 2

Now it was the practice of his parents to go to Jerusalem every year for the Passover festival; and *when he was twelve,* they made the pilgrimage as usual.

When the festive season was over and they started for home, the boy Jesus stayed behind in Jerusalem.

His parents did not know of this; but thinking that he was with the party they journeyed on for a whole day, and only then did they begin looking for him among their friends and relations.

As they could not find him they returned to Jerusalem to look for him; and after three days they found him sitting in the temple surrounded by the teachers, listening to them and putting questions; and all who heard him were amazed at his intelligence and the answers he gave.

...all who heard him were amazed...

— LUKE 2

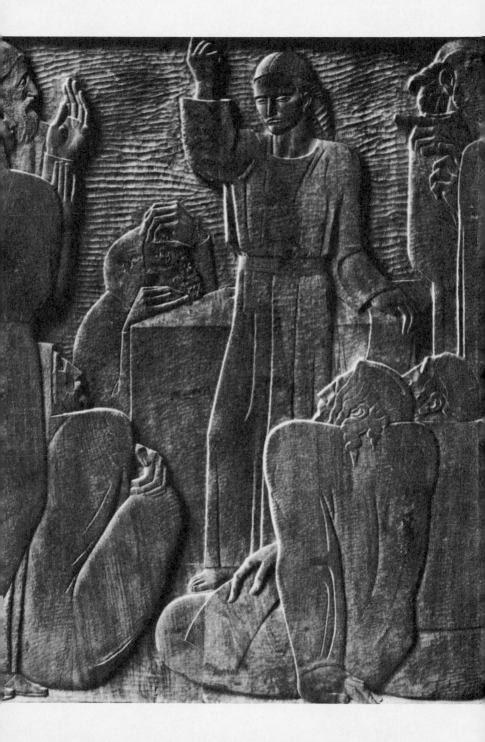

His parents were astonished to see him there, and his mother said to him, 'My son, why have you treated us like this?

Your father and I have been searching for you in great anxiety.'

'What made you search?' he said.

'Did you not know that I was bound to be in my Father's house?'

But they did not understand what he meant.

Then he went back with them to Nazareth, and continued to be under their authority; his mother treasured up all these things in her heart.

As Jesus grew up he advanced in wisdom and in favour with God and men.

— Luke 2

So he came to Nazareth, where he had been brought up, and went to synagogue on the Sabbath day as he regularly did.

He stood up to read the lesson and was handed the scroll of the prophet Isaiah.

He opened the scroll and found the passage which says,

'The spirit of the Lord is upon me because he has anointed me;
he has sent me to announce good news to the poor,
to proclaim release for prisoners and recovery of sight for the blind;
to let the broken victims go free,
to proclaim the year of the Lord's favour.'

He rolled up the scroll, gave it back to the attendant, and sat down; and all eyes in the synagogue were fixed on him.

He began to speak: *'Today'*, *he said, 'in your very hearing this text has come true.'*

There was a general stir of admiration; they were surprised that words of such grace should fall from his lips.

'Is not this Joseph's son?' they asked.

— LUKE 4

About that time John the Baptist appeared as a preacher in the Judaean wilderness; his theme was: 'Repent; for the kingdom of Heaven is upon you!'

It is of him that the prophet Isaiah spoke when he said, 'A voice crying aloud in the wilderness, "Prepare a way for the Lord; clear a straight path for him."'

John's clothing was a rough coat of camel's hair, with a leather belt round his waist, and his food was locusts and wild honey.

They flocked to him from Jerusalem, from all Judaea, and the whole Jordan valley, and were baptized by him in the River Jordan, confessing their sins.

.

Then Jesus arrived at the Jordan from Galilee, and came to John to be baptized by him. . . .

After baptism Jesus came up out of the water at once, and at that moment heaven opened; he saw the Spirit of God descending like a dove to alight upon him; and a voice from heaven was heard saying, *This is my Son, my Beloved, on whom my favour rests.*

— Matthew 3

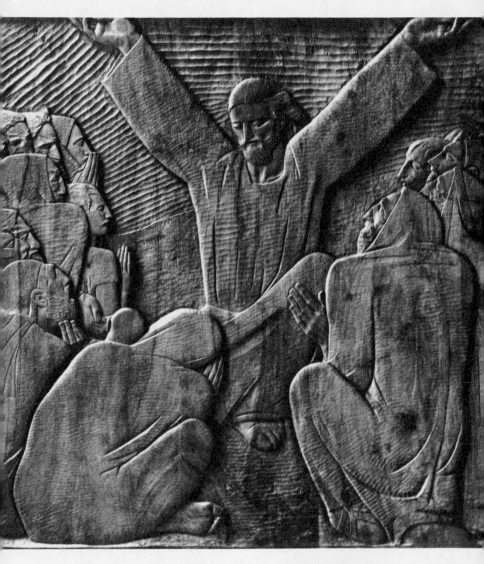

When (Jesus) saw the crowds he went up the hill.

— MATTHEW 5

When [Jesus] saw the crowds he went up the hill.

There he took his seat, and when his disciples had gathered round him he began to address them.

And this is the teaching he gave:

'How blest are those who know their
 need of God; the kingdom of Heaven
 is theirs.
How blest are the sorrowful;
 they shall find consolation.
How blest are those of a gentle spirit;
 they shall have the earth for their
 possession.
How blest are those who hunger and
 thirst to see right prevail;
 they shall be satisfied.
How blest are those who show mercy;
 mercy shall be shown to them.
How blest are those whose hearts are
 pure;
 they shall see God.
How blest are the peacemakers;
 God shall call them his sons.

25

How blest are those who have suffered
persecution for the cause of right;
the kingdom of Heaven is theirs.

'How blest you are, when you suffer
insults and persecution and every kind of
calumny for my sake.
Accept it with gladness and exultation,
for you have a rich reward in heaven; in
the same way they persecuted the prophets
before you.'

— MATTHEW 5

'You have learned that they were told, "Eye for eye, tooth for tooth."

But what I tell you is this: Do not set yourself against the man who wrongs you.

If someone slaps you on the right cheek, *turn and offer him your left*.

If a man wants to sue you for your shirt, let him have your coat as well.

If a man in authority makes you go one mile, go with him two.

Give when you are asked to give; and do not turn your back on a man who wants to borrow.'

— Matthew 5

'You have learned that they were told, "Love your neighbour, hate your enemy."

But what I tell you is this: Love your enemies and pray for your persecutors; only so can you be children of your heavenly Father, who makes his sun rise on good and bad alike, and sends the rain on the honest and the dishonest.

If you love only those who love you, what reward can you expect?

Surely the tax-gatherers do as much as that.

And if you greet only your brothers, what is there extraordinary about that?

Even the heathen do as much.

There must be *no limit to your goodness,* as your heavenly Father's goodness knows no bounds.'

— MATTHEW 5

'If, when you are bringing your gift to the altar, you suddenly remember that your brother has a grievance against you, leave your gift where it is before the altar.

First go and *make your peace with your brother,* and only then come back and offer your gift.

'If someone sues you, come to terms with him promptly while you are both on your way to court; otherwise he may hand you over to the judge, and the judge to the constable, and you will be put in jail.

I tell you, once you are there you will not be let out till you have paid the last farthing.

'You have learned that they were told, "Do not commit adultery."

But what I tell you is this: If a man looks on a woman with a lustful eye, he has already committed adultery with her in his heart.'

— MATTHEW 5

'This is how you should pray:

"Our Father in heaven,
thy name be hallowed;
thy kingdom come,
thy will be done,
on earth as in heaven.
Give us today our daily bread.
Forgive us the wrong we have done,
as we have forgiven those who have
 wronged us.
And do not bring us to the test,
but save us from the evil one."

'For if you forgive others the wrongs
they have done, your heavenly Father will
also forgive you; but if you do not forgive
others, then the wrongs you have done
will not be forgiven by your Father.'

— MATTHEW 6

'Be careful not to make a show of your religion before men; if you do, no reward awaits you in your Father's house in heaven.

'Thus, when you do some act of charity, do not announce it with a flourish of trumpets, as the hypocrites do in synagogue and in the streets to win admiration from men.

I tell you this: they have their reward already.

No; when you do some act of charity, do not let your left hand know what your right is doing; *your deed must be secret,* and your Father who sees what is done in secret will reward you.

'Again, when you pray, do not be like the hypocrites; they love to say their prayers standing up in synagogue and at the street-corners, for everyone to see them.

I tell you this: they have their reward already.

But when you pray, go into a room by yourself, shut the door, and pray to your Father who is there in the secret place; and your Father who sees what is secret will reward you.

'In your prayers do not go babbling on like the heathen, who imagine that the more they say the more likely they are to be heard.

Do not imitate them.

Your Father knows what your needs are before you ask him.'

— MATTHEW 6

'So too when you fast, do not look gloomy like the hypocrites: they make their faces unsightly so that other people may see that they are fasting.

I tell you this: they have their reward already.

But when you fast, anoint your head and wash your face, so that men may not see that you are fasting, but only your Father who is in the secret place; and your Father who sees what is secret will give you your reward.'

— MATTHEW 6

'*Pass no judgement,* and you will not be judged.

For as you judge others, so you will yourselves be judged, and whatever measure you deal out to others will be dealt back to you.

Why do you look at the speck of sawdust in your brother's eye, with never a thought for the great plank in your own?

Or how can you say to your brother, "Let me take the speck out of your eye", when all the time there is that plank in your own?

You hypocrite!

First take the plank out of your own eye, and then you will see clearly to take the speck out of your brother's.'

— MATTHEW 7

'Therefore I bid you put away anxious thoughts about food and drink to keep you alive, and clothes to cover your body.

Surely life is more than food, the body more than clothes.

Look at the birds of the air; they do not sow and reap and store in barns, yet your heavenly Father feeds them.

You are worth more than the birds!

Is there a man of you who by anxious thought can add a foot to his height?

And why be anxious about clothes?

Consider how the lilies grow in the fields; they do not work, they do not spin; and yet, I tell you, even Solomon in all his splendour was not attired like one of these.

But if that is how God clothes the grass in the fields, which is there today, and tomorrow is thrown on the stove, will he not all the more clothe you?

How little faith you have!

No, do not ask anxiously, "What are we to eat?

What are we to drink?

What shall we wear?"

All these are things for the heathen to run after, not for you, because your heavenly Father knows that you need them all.

Set your mind on God's kingdom and his justice before everything else, and all the rest will come to you as well.

So do not be anxious about tomorrow; tomorrow will look after itself.

Each day has troubles enough of its own.'

— MATTHEW 6

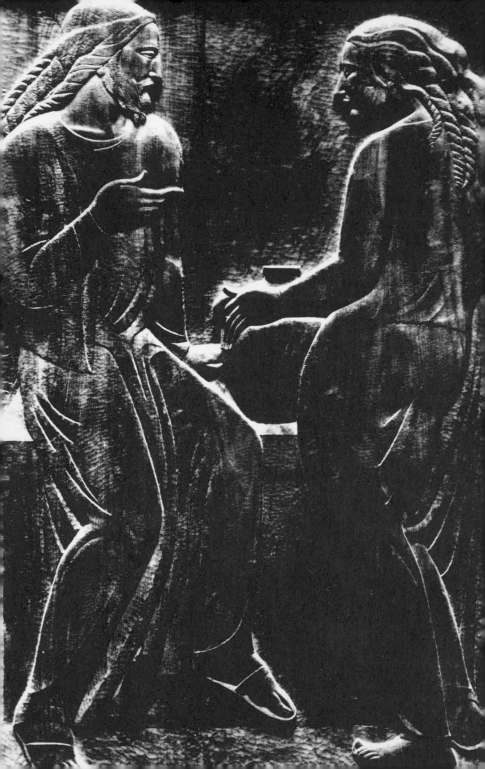

Meanwhile a Samaritan woman came to draw water.

Jesus said to her, 'Give me a drink.'

The Samaritan woman said, 'What! You, a Jew, ask a drink of me, a Samaritan woman?'

(Jews and Samaritans, it should be noted, do not use vessels in common.)

Jesus answered her, 'If only you knew what God gives, and who it is that is asking you for a drink, you would have asked him and he would have given you living water.'

'Sir,' the woman said, 'you have no bucket and this well is deep.

How can you give me "living water"?

Are you a greater man than Jacob our ancestor, who gave us the well, and drank from it himself, he and his sons, and his cattle too?'

'The water that I shall give him
will be an inner spring
always welling up for eternal life.'

— JOHN 4

Jesus said, 'Everyone who drinks this water will be thirsty again, but whoever drinks the water that I shall give him will never suffer thirst any more.

The water that I shall give him will be *an inner spring always welling up* for eternal life.'

'Sir,' said the woman, 'give me that water, and then I shall not be thirsty, nor have to come all this way to draw.'

— JOHN 4

As [Jesus] was starting out on a journey, a stranger ran up, and, kneeling before him, asked, 'Good Master, what must I do to win eternal life?'

Jesus said to him, . . .

'You know the commandments: "Do not murder; do not commit adultery; do not steal; do not give false evidence; do not defraud; honour your father and mother." '

'But, Master,' he replied, 'I have kept all these since I was a boy.'

Jesus looked straight at him; his heart warmed to him, and he said, 'One thing you lack: go, sell everything you have, and *give to the poor,* and you will have riches in heaven; and come, follow me.'

At these words his face fell and he went away with a heavy heart; for he was a man of great wealth.

Jesus looked round at his disciples and said to them, 'How hard it will be for the wealthy to enter the kingdom of God!'

They were amazed that he should say this, but Jesus insisted, 'Children, how hard it is to enter the kingdom of God!

It is easier for a camel to pass through the eye of a needle than for a rich man to enter the kingdom of God.'

They were more astonished than ever, and said to one another, 'Then who can be saved?'

Jesus looked at them and said, 'For men it is impossible, but not for God; everything is possible for God.'

—MARK 10

One of the Pharisees invited [Jesus] to eat with him; he went to the Pharisee's house and took his place at table.

A woman who was living an immoral life in the town had learned that Jesus was at table in the Pharisee's house and had brought oil of myrrh in a small flask.

She took her place behind him, by his feet, weeping.

His feet were wetted with her tears and she wiped them with her hair, kissing them and anointing them with the myrrh.

When his host the Pharisee saw this he said to himself, 'If this fellow were a real prophet, he would know who this woman is that touches him, and what sort of woman she is, a sinner.'

Jesus took him up and said, 'Simon, I have something to say to you.'

'Speak on, Master', said he.

'Two men were in debt to a money-lender: one owed him five hundred silver pieces, the other fifty.

As neither had anything to pay with he let them both off.

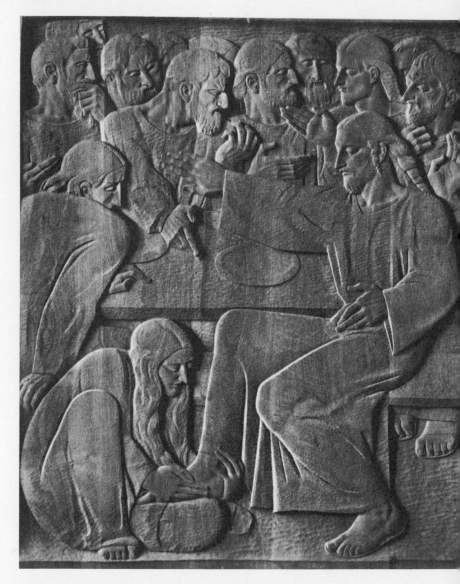

His feet were wetted with (Magdalen's) tears
and she wiped them with her hair . . .

— LUKE 7

Now, which will love him most?'

Simon replied, 'I should think the one that was let off most.'

'You are right', said Jesus.

Then turning to the woman, he said to Simon, 'You see this woman?

I came to your house: you provided no water for my feet; but this woman has made my feet wet with her tears and wiped them with her hair.

You gave me no kiss; but she has been kissing my feet ever since I came in.

You did not anoint my head with oil; but she has anointed my feet with myrrh.

And so, I tell you, her great love proves that her many sins have been forgiven; *where little has been forgiven, little love is shown.*'

Then he said to her, 'Your sins are forgiven.'

The other guests began to ask themselves, 'Who is this, that he can forgive sins?'

But he said to the woman, 'Your faith has saved you; go in peace.'

— LUKE 7

Entering Jericho [Jesus] made his way through the city.

There was a man there named Zacchaeus; he was superintendent of taxes and very rich.

He was eager to see what Jesus looked like; but, being a little man, he could not see him for the crowd.

So he ran on ahead and climbed a sycamore tree in order to see him, for he was to pass that way.

When Jesus came to the place, he looked up and said, 'Zacchaeus, be quick and come down; I must come and stay with you today.'

He climbed down as fast as he could and welcomed him gladly.

At this there was a general murmur of disapproval.

'He has gone in', they said, 'to be the guest of a sinner.'

But Zacchaeus stood there and said to the Lord, 'Here and now, sir, *I give half my possessions to charity;* and if I have cheated anyone, I am ready to repay him four times over.'

Jesus said to him, 'Salvation has come to this house today!'

—LUKE 19

Then he said to them, 'Suppose one of you has a friend who comes to him in the middle of the night and says, "My friend, lend me three loaves, for a friend of mine on a journey has turned up at my house, and I have nothing to offer him"; and he replies from inside, "Do not bother me.

The door is shut for the night; my children and I have gone to bed; and I cannot get up and give you what you want."

I tell you that even if he will not provide for him out of friendship, the very shamelessness of the request will make him get up and give him all he needs.

And so I say to you, ask, and you will receive; seek, and you will find; *knock, and the door will be opened.*

For everyone who asks receives, he who seeks finds, and to him who knocks, the door will be opened.'

—LUKE 11

Then a woman who had suffered from hemorrhages for twelve years came up from behind, and touched the edge of his cloak; for she said to herself, 'If I can only touch his cloak, I shall be cured.'

But Jesus turned and saw her, and said, 'Take heart, my daughter; your faith has cured you.'

And from that moment she recovered.

.

At that time Jesus spoke these words: 'I thank thee, Father, Lord of heaven and earth, for hiding these things from the learned and wise, and revealing them to the simple.

.

'Come to me, all whose work is hard, whose load is heavy; and I will give you relief.

Bend your necks to my yoke, and learn from me, *for I am gentle and humble-hearted*; and your souls will find relief.

For my yoke is good to bear, my load is light.'

— MATTHEW 9, 11

'Come to me, all whose work is hard, whose load
is heavy; and I will give you relief.'

— MATTHEW 11

48

'There is no such thing as a good tree producing worthless fruit, nor yet a worthless tree producing good fruit.

For each tree is known by its own fruit: you do not gather figs from thistles, and you do not pick grapes from brambles.

A good man produces good from the store of good within himself; and an evil man from evil within produces evil.

For the words that the mouth utters come from the overflowing of the heart.'

— LUKE 6

'What then of the man who hears these words of mine and acts upon them?

He is like a man who had the sense *to build his house on rock*.

The rain came down, the floods rose, the wind blew, and beat upon that house; but it did not fall, because its foundations were on rock.

But what of the man who hears these words of mine and does not act upon them?

He is like a man who was foolish enough to build his house on sand.

The rain came down, the floods rose, the wind blew, and beat upon that house; down it fell with a great crash.'

— MATTHEW 7

Then [Jesus] said to his host, 'When you are having a party for lunch or supper, do not invite your friends, your brothers or other relations, or your rich neighbours; they will only ask you back again and so you will be repaid.

But *when you give a party, ask the poor*, the crippled, the lame, and the blind; and so find happiness.

For they have no means of repaying you; but you will be repaid on the day when good men rise from the dead.'

—LUKE 14

On one occasion a lawyer came forward to put this test question to him: 'Master, what must I do to inherit eternal life?'

Jesus said, 'What is written in the Law? What is your reading of it?'

He replied, 'Love the Lord your God with all your heart, with all your soul, with all your strength, and with all your mind; and your neighbour as yourself.'

'That is the right answer,' said Jesus; 'do that and you will live.'

But he wanted to vindicate himself, so he said to Jesus, 'And who is my neighbour?'

Jesus replied, 'A man was on his way from Jerusalem down to Jericho when he fell in with robbers, who stripped him, beat him, and went off leaving him half dead.

It so happened that a priest was going down by the same road: but when he saw him, he went past on the other side.

So too a Levite came to the place, and when he saw him went past on the other side.

But a Samaritan who was making the journey came upon him, and when he saw him was moved to pity.

He went up and bandaged his wounds, bathing them with oil and wine.

Then he lifted him on to his own beast, brought him to an inn, and looked after him there.

Next day he produced two silver pieces and gave them to the innkeepr, and said, "Look after him; and if you spend any more, I will repay you on my way back."

Which of these three do you think was neighbour to the man who fell into the hands of the robbers?'

He answered, '*The one who showed him kindness.*'

Jesus said, 'Go and do as he did.'

—LUKE 10

'...this poor widow has given more
than any of the others ...'

— MARK 12

Once he was standing opposite the temple treasury, watching as people dropped their money into the chest.

Many rich people were giving large sums.

Presently there came a poor widow who dropped in two tiny coins, together worth a farthing.

He called his disciples to him.

'I tell you this', he said: 'this poor widow has given more than any of the others; for those others who have given had more than enough, but *she, with less than enough, has given all that she had to live on.*'

.

There was a great crowd and they listened eagerly.

He said as he taught them, 'Beware of the doctors of the law, who love to walk up and down in long robes, receiving respectful greetings in the street; and to have the chief seats in synagogues, and places of honour at feasts.

These are the men who eat up the property of widows, while they say long prayers for appearance' sake, and they will receive the severest sentence.'

—Mark 12

And this is another parable that [Jesus] put before them: 'The kingdom of Heaven is like a mustard-seed, which a man took and sowed in his field.

As a seed, mustard is smaller than any other; but when it has grown it is bigger than any garden-plant; it becomes a tree, big enough for the birds to come and roost among its branches.'

He told them also this parable: 'The kingdom of Heaven is like yeast, which a woman took and mixed with half a hundredweight of flour till it was all leavened.'

.

'*The kingdom of Heaven is like treasure* lying buried in a field.

The man who found it, buried it again; and for sheer joy went and sold everything he had, and bought that field.

'Here is another picture of the kingdom of Heaven. A merchant looking out for fine pearls found one of very special value; so he went and sold everything he had, and bought it.'

— MATTHEW 13

When [Jesus] noticed how the guests were trying to secure the places of honour, he spoke to them in a parable: 'When you are asked by someone to a wedding-feast, do not sit down in the place of honour.

It may be that some person more distinguished than yourself has been invited; and the host will come and say to you, "Give this man your seat."

Then you will look foolish as you begin to take the lowest place.

No, when you receive an invitation, go and sit down in the lowest place, so that when your host comes he will say, *"Come up higher, my friend."*

Then all your fellow-guests will see the respect in which you are held.

For everyone who exalts himself will be humbled; and whoever humbles himself will be exalted.'

—LUKE 14

Again [Jesus] said: 'There was once a man who had two sons; and the younger said to his father, "Father, give me my share of the property."

So he divided his estate between them.

A few days later the younger son turned the whole of his share into cash and left home for a distant country, where he squandered it in reckless living.

He had spent it all, when a severe famine fell upon that country and he began to feel the pinch.

So he went and attached himself to one of the local landowners, who sent him on to his farm to mind the pigs.

He would have been glad to fill his belly with the pods that the pigs were eating; and no one gave him anything.

Then he came to his senses and said, "How many of my father's paid servants have more food than they can eat, and here am I, starving to death!

I will set off and go to my father, and say to him, 'Father, I have sinned, against God and against you; I am no longer fit to be called your son; treat me as one of your paid servants.' "

So he set out for his father's house.

But while he was still a long way off his father saw him, and his heart went out to him.

He ran to meet him, flung his arms round him, and kissed him.

The son said, "Father, I have sinned, against God and against you; I am no longer fit to be called your son."

But the father said to his servants, "Quick! fetch a robe, my best one, and put it on him; put a ring on his finger and shoes on his feet.

Bring the fatted calf and kill it, and let us have a feast to celebrate the day.

For this son of mine was dead and has come back to life; he was lost and is found."

And the festivities began.

'Now the elder son was out on the farm; and on his way back, as he approached the house, he heard music and dancing.

He called one of the servants and asked what it meant.

The servant told him, "Your brother has come home, and your father has killed the fatted calf because he has him back safe and sound."

But he was angry and refused to go in.

His father came out and pleaded with him; but he retorted, "You know how I have slaved for you all these years; I never once disobeyed your orders; and you never gave me so much as a kid, for a feast with my friends.

But now that this son of yours turns up, after running through your money with his women, you kill the fatted calf for him."

"My boy," said the father, "you are always with me, and everything I have is yours.

How could we help celebrating this happy day?

Your brother here was dead and has come back to life, was lost and is found."'

—Luke 15

'Suppose one of you has a servant ploughing or minding sheep.

When he comes back from the fields, will the master say, "Come along at once and sit down"?

Will he not rather say, "Prepare my supper, fasten your belt, and then wait on me while I have my meal; you can have yours afterwards"?

Is he grateful to the servant for carrying out his orders?

So with you: when you have carried out all your orders, you should say, "We are servants and deserve no credit; we have only done our duty." '

.　.　.　.　.　.　.　.　.

Then a jealous dispute broke out: who among them should rank highest?

But [Jesus] said, 'In the world, kings lord it over their subjects; and those in authority are called their country's "Benefactors".

Not so with you: on the contrary, the highest among you must bear himself like the youngest, the chief of you like a servant.

60

For who is greater — the one who sits
at table or the servant who waits on him?
Surely the one who sits at table.
Yet here am I among you like a servant.'

<div align="right">—Luke 17, 22</div>

So Jesus called them to him and said,
'You know that in the world, rulers lord
over their subjects, and their great men
make them feel the weight of authority;
but it shall not be so with you.

Among you, whoever wants to be great
must be your servant, and whoever wants
to be first must be the willing slave of all
—like the Son of Man; *he did not come to
be served, but to serve, and to give up his
life as a ransom for many.'*

<div align="right">— Matthew 20</div>

61

At his birthday celebrations the daughter of Herodias danced before the guests, and Herod was so delighted that he took an oath to give her anything she cared to ask.

Prompted by her mother, she said, *'Give me here on a dish the head of John the Baptist.'*

The king was distressed when he heard it; but out of regard for his oath and for his guests, he ordered the request to be granted, and had John beheaded in prison.

The head was brought in on a dish and given to the girl; and she carried it to her mother.

Then John's disciples came and took away the body, and buried it; and they went and told Jesus.

When he heard what had happened Jesus withdrew privately by boat to a lonely place; but people heard of it, and came after him in crowds by land from the towns.

— MATTHEW 14

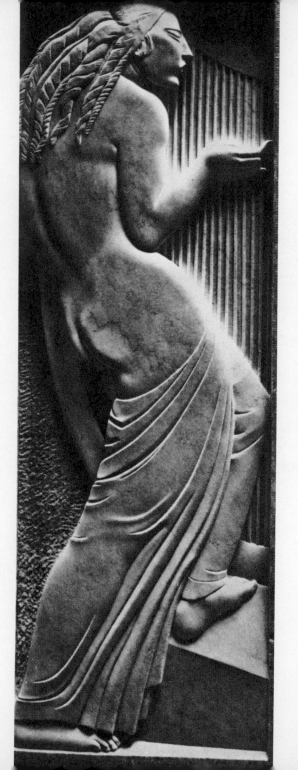

'...*Give me here*
on a dish the head
of John the Baptist.'
— MATTHEW 14

After John's messengers had left, Jesus began to speak about him to the crowds: 'What was the spectacle that drew you to the wilderness?

A reedbed swept by the wind?

No?

Then what did you go out to see?

A man dressed in silks and satins?

Surely you must look in palaces for grand clothes and luxury.

But what did you go out to see?

A prophet?

Yes indeed, and far *more than a prophet*.

He is the man of whom Scripture says,

"Here is my herald, who I send on ahead of you,
and he will prepare your way before you."

I tell you, there is not a mother's son greater than John, and yet the least in the kingdom of God is greater than he.'

— LUKE 7

'The man who can be trusted in little things can be trusted also in great; and the man who is dishonest in little things is dishonest also in great things.

If, then, you have not proved trustworthy with the wealth of this world, who will trust you with the wealth that is real?

And if you have proved untrustworthy with what belongs to another, who will give you what is your own?

'No servant can be the slave of two masters; for either he will hate the first and love the second, or he will be devoted to the first and think nothing of the second.

You cannot serve God and Money.'

The Pharisees, *who loved money*, heard all this and scoffed at him.

He said to them, 'You are the people who impress your fellow-men with your righteousness; but God sees through you; for what sets itself up to be admired by men is detestable in the sight of God.'

—LUKE 16

'There was once a rich man, who dressed in purple and the finest linen, and feasted in great magnificence every day.

At his gate, covered with sores, lay *a poor man named Lazarus,* who would have been glad to satisfy his hunger with the scraps from the rich man's table.

Even the dogs used to come and lick his sores.

One day the poor man died and was carried away by the angels to be with Abraham.

The rich man also died and was buried, and in Hades, where he was in torment, he looked up; and there, far away, was Abraham with Lazarus close beside him.

"Abraham, my father," he called out, "take pity on me!

Send Lazarus to dip the tip of his finger in water, to cool my tongue, for I am in agony in this fire."

But Abraham said, "Remember, my child, that all the good things fell to you while you were alive, and all the bad to Lazarus; now he has his consolation here and it is you who are in agony.

But that is not all: there is a great chasm fixed between us; no one from one side who wants to reach you can cross it, and none may pass from your side to us."

"Then, father," he replied, "will you send him to my father's house, where I have five brothers, to warn them, so that they too may not come to this place of torment?"

But Abraham said, "They have Moses and the prophets; let them listen to them."

"No, father Abraham," he replied, "but if someone from the dead visits them, they will repent."

Abraham answered, "If they do not listen to Moses and the prophets they will pay no heed even if someone should rise from the dead." '

—LUKE 16

Once about that time Jesus went through the cornfields on the Sabbath; and his disciples, feeling hungry, began to pluck some ears of corn and eat them.

The Pharisees noticed this, and said to him, 'Look, your disciples are doing something which is forbidden on the Sabbath.'

He answered, 'Have you not read what David did when he and his men were hungry?

He went into the House of God and ate the sacred bread, though neither he nor his men had a right to eat it, but only the priests.

Or have you not read in the Law that on the Sabbath the priests in the temple break the Sabbath and it is not held against them?

I tell you, there is something greater than the temple here.

If you had known what that text means, "I require *mercy, not sacrifice*", you would not have condemned the innocent.

For the Son of Man is sovereign over the Sabbath.'

— Matthew 12

'For John the Baptist came neither eating bread nor drinking wine, and you say, "He is possessed."

The Son of Man came eating and drinking, and you say, "Look at him! a glutton and a drinker, a friend of tax-gatherers and sinners!"

And yet God's wisdom is proved right by all who are her children.'

—LUKE 7

'The kingdom of Heaven, therefore, should be thought of in this way: There was once a king who decided to settle accounts with the men who served him.

At the outset there appeared before him a man whose debt ran into millions.

Since he had no means of paying, his master ordered him to be sold to meet the debt, with his wife, his children, and everything he had.

The man fell prostrate at his master's feet.

"Be patient with me," he said, "and I will pay in full"; and the master was so moved with pity that he let the man go and remitted the debt.

But no sooner had the man gone out than he met a fellow-servant who owed him a few pounds; and catching hold of him he gripped him by the throat and said, "Pay me what you owe."

The man fell at his fellow-servant's feet, and begged him, "Be patient with me, and I will pay you"; but he refused, and had him jailed until he should pay the debt.

The other servants were deeply distressed when they saw what had happened, and they went to their master and told him the whole story.

He accordingly sent for the man.

"You scoundrel!" he said to him; "I remitted the whole of your debt when you appealed to me; were you not bound to show your fellow-servant the same pity as I showed you?"

And so angry was the master that he condemned the man to torture until he should pay the debt in full.

And that is how my heavenly Father will deal with you, unless you each forgive your brother from your hearts.'

— MATTHEW 18

'If your brother commits a sin, go and take the matter up with him, strictly between yourselves, and if he listens to you, you have won your brother over.

If he will not listen, take one or two others with you, so that all facts may be duly established on the evidence of two or three witnesses.

If he refuses to listen to them, report the matter to the congregation; and if he will not listen even to the congregation, you must then treat him as you would a pagan or a tax-gatherer.'

.

Then Peter came up and asked him, 'Lord, how often am I to forgive my brother if he goes on wronging me? As many as seven times?'

Jesus replied, 'I do not say seven times; *I say seventy times seven.*'

— MATTHEW 18

'If your brother wrongs you, reprove him; and if he repents, forgive him.

Even if he wrongs you seven times in a day and comes back to you seven times saying, "I am sorry", you are to forgive him.'

— LUKE 17

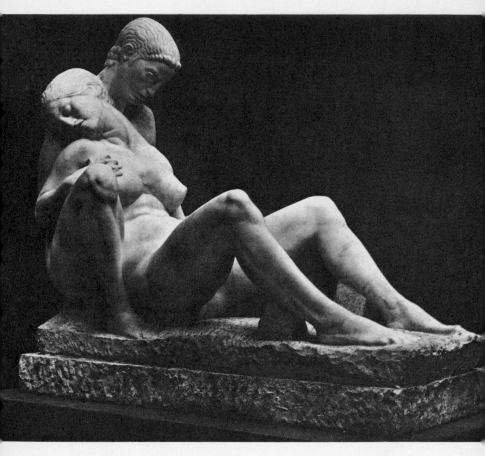

'...*they are one flesh*.'

— Matthew 19

Some Pharisees came and tested [Jesus] by asking, 'Is it lawful for a man to divorce his wife on any and every ground?'

He asked in return, 'Have you never read that the Creator made them from the beginning male and female?'; and he added, 'For this reason a man shall leave his father and mother, and be made one with his wife; and the two shall become one flesh.

It follows that they are no longer two individuals: *they are one flesh.*

What God has joined together, man must not separate.'

'Why then', they objected, 'did Moses lay it down that a man might divorce his wife by note of dismissal?'

He answered, 'It was because your minds were closed that Moses gave you permission to divorce your wives; but it was not like that when all began.

I tell you, if a man divorces his wife for any cause other than unchastity, and marries another, he commits adultery.'

The disciples said to him, 'If that is the position with husband and wife, it is better not to marry.'

To this he replied, 'That is something which not everyone can accept, but only those for whom God has appointed it.

For while some are incapable of marriage because they were born so, or were made so by men, there are others who have themselves renounced marriage for the sake of the kingdom of Heaven.

Let those accept it who can.'

They brought children for him to lay his hands on them with prayer.

The disciples rebuked them, but Jesus said to them, 'Let the children come to me; do not try to stop them; for the kingdom of Heaven belongs to such as these.'

And he laid his hands on the children, and went his way.

— MATTHEW 19

'... *the kingdom of heaven*
belongs to such as these.'
— MATTHEW 19

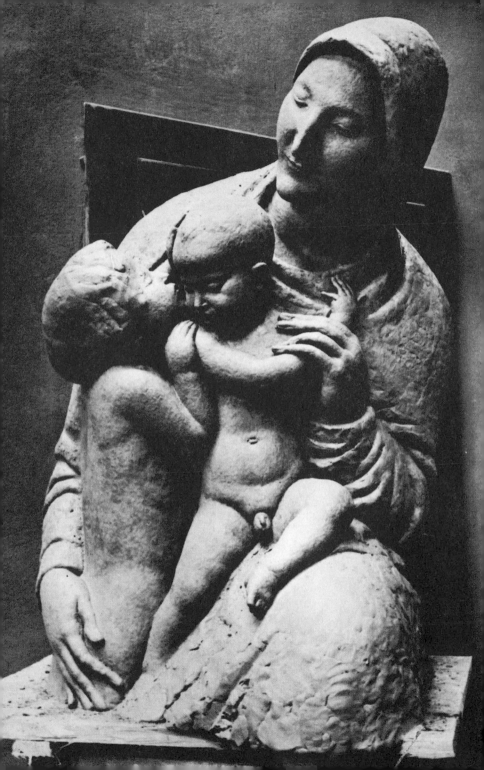

At that time the disciples came to Jesus and asked, 'Who is the greatest in the kingdom of Heaven?'

He called a child, set him in front of them, and said, 'I tell you this: unless you turn round and become like children, you will never enter the kingdom of Heaven.

Let a man humble himself till he is *like this child*, and he will be the greatest in the kingdom of Heaven.

Whoever receives one such child in my name receives me.

But if a man is a cause of stumbling to one of these little ones who have faith in me, it would be better for him to have a millstone hung round his neck and be drowned in the depths of the sea.

Alas for the world that such causes of stumbling arise!

Come they must, but woe betide the man through whom they come!'

— MATTHEW 18

Another time, the tax-gatherers and other bad characters were all crowding in to listen to [Jesus]; and the Pharisees and the doctors of the law began grumbling among themselves: 'This fellow', they said, 'welcomes sinners and eats with them.'

He answered them with this parable: 'If one of you has a hundred sheep and loses one of them does he not leave the ninety-nine in the open pasture and go after the missing one until he has found it?

How delighted he is then!

He lifts it on to his shoulders, and home he goes to call his friends and neighbours together.

"Rejoice with me!" he cries.

"I have found my lost sheep."

In the same way, I tell you, there will be greater joy in heaven over one sinner who repents than over ninety-nine righteous people who do not need to repent.'

—Luke 15

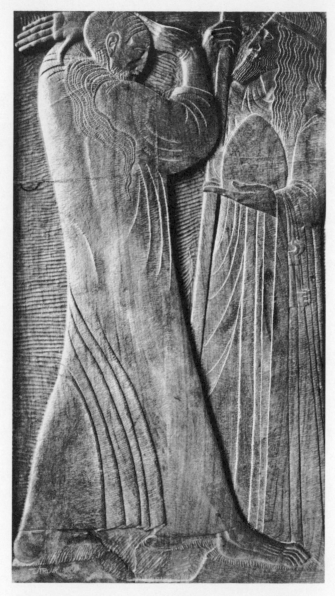

'You pay tithes of mint and dill and cummin;
but you have overlooked the weightier demands
of the Law, justice, mercy, and good faith.'
— MATTHEW 23

'Alas for you, lawyers and Pharisees, hypocrites!

You pay tithes of mint and dill and cummin; but you have overlooked the weightier demands of the Law, justice, mercy, and good faith.

It is these you should have practiced, without neglecting the others.

Blind guides!

You strain off a midge, yet gulp down a camel!

'. . .You clean the outside of cup and dish, which you have filled inside by robbery and self-indulgence!

Blind Pharisee!

Clean the inside of the cup first; then the outside will be clean also.

'. . . You are like tombs covered with whitewash; they look well from the outside, but inside they are full of dead men's bones and all kinds of filth.

So it is with you: outside you look like honest men, but inside you are brim-full of hypocrisy and crime.'

— MATTHEW 23

Then Jesus was approached by a group
of Pharisees and lawyers from Jerusalem,
with the question: 'Why do your disciples
break the ancient tradition?

They do not wash their hands before
meals.' . . .

He called the crowd and said to them,
'Listen to me, and understand this: a man
is not defiled by what goes into his mouth,
but by what comes out of it.'

Then the disciples came to him and said,
'Do you know that the Pharisees have
taken great offence at what you have been
saying?'

His answer was: 'Any plant that is not
of my heavenly Father's planting will be
rooted up.

Leave them alone; they are blind guides,
and if one blind man guides another they
will both fall into the ditch.'

Then Peter said, 'Tell us what that par-
able means.'

Jesus answered, 'Are you still as dull as the rest?

Do you not see that whatever goes in by the mouth passes into the stomach and so is discharged into the drain?

But what comes out of the mouth has its origins in the heart; and that is what defiles a man.

Wicked thoughts, murder, adultery, fornication, theft, perjury, slander — these all proceed from the heart; and these are the things that defile a man; but to eat without first washing his hands, that cannot defile him.'

— MATTHEW 15

These twelve Jesus sent out with the following instructions: 'Do not take the road to gentile lands, and do not enter any Samaritan town; but go rather to the lost sheep of the house of Israel.

And as you go proclaim the message: "The kingdom of Heaven is upon you."

Heal the sick, raise the dead, cleanse lepers, cast out devils.

You received without cost; give without charge.

'Provide no gold, silver, or copper to fill your purse, no pack for the road, no second coat, no shoes, no stick; the worker earns his keep.

'When you come to any town or village, look for some worthy person in it, and make your home there until you leave.

Wish the house peace as you enter it, so that, if it is worthy, your peace may descend on it; if it is not worthy, your peace can come back to you.

If anyone will not receive you or listen to what you say, then as you leave that

house or that town shake the dust of it off your feet.

I tell you this: on the day of judgement it will be more bearable for the land of Sodom and Gomorrah than for that town.

.

Jesus then said to his disciples, 'If anyone wishes to be a follower of mine, he must leave self behind; he must take up his cross and come with me.

Whoever cares for his own safety is lost; but if a man will let himself be lost for my sake, he will find his true self.

What will a man gain by winning the whole world, at *the cost of his true self?*

Or what can he give that will buy that self back?'

— MATTHEW 10, 16

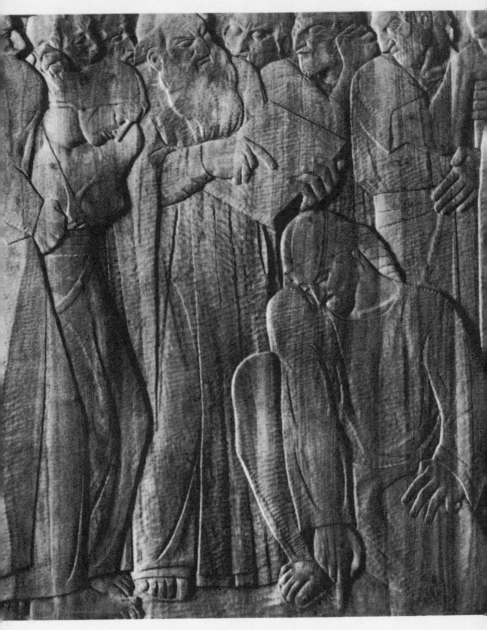

... 'That one of you who is faultless
shall throw the first stone.'

— JOHN 8

[J esus] appeared again in the temple, and all the people gathered round him.

He had taken his seat and was engaged in teaching them when the doctors of the law and the Pharisees brought in a woman caught committing adultery.

Making her stand out in the middle they said to him, 'Master, this woman was caught in the very act of adultery.

In the Law Moses has laid down that such women are to be stoned.

What do you say about it?'

They put the question as a test, hoping to frame a charge against him.

Jesus bent down and wrote with his finger on the ground.

When they continued to press their question he sat up straight and said, 'That one of you who is faultless shall *throw the first stone.*'

Then once again he bent down and wrote on the ground.

When they heard what he said, one by one they went away, the eldest first; and

Jesus was left alone, with the woman still standing there.

Jesus again sat up and said to the woman, 'Where are they?

Has no one condemned you?'

She answered, 'No one, sir.'

Jesus said, 'Nor do I condemn you. You may go; do not sin again.'

— JOHN 8

[*Then Jesus spoke to them about the Last Judgement:*]

'Then the king [the Son of Man] will say to those on his right hand, "You have my Father's blessing; come, enter and possess the kingdom that has been ready for you since the world was made.

For when I was hungry, you gave me food; when thirsty, *you gave me drink;* when I was a stranger you took me into your home, when naked you clothed me; when I was ill you came to my help, when in prison you visited me."

Then the righteous will reply, "Lord, when was it that we saw you hungry and fed you, or thirsty and gave you drink, a stranger and took you home, or naked and clothed you?

When did we see you ill or in prison, and come to visit you?"

And the king will answer, "I tell you this: anything you did for one of my brothers here, however humble, you did for me."

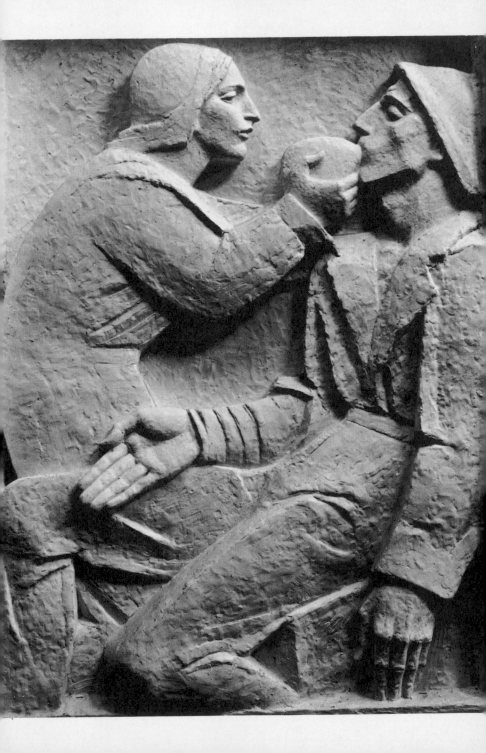

Then he will say to those on his left hand, "The curse is upon you; go from my sight to the eternal fire that is ready for the devil and his angels.

For when I was hungry you gave me nothing to eat, when thirsty nothing to drink; when I was a stranger you gave me no home, when naked you did not clothe me; when I was ill and in prison you did not come to my help."

And they too will reply, "Lord, when was it that we saw you hungry or thirsty or a stranger or naked or ill or in prison, and did nothing for you?"

And he will answer, "I tell you this: anything you did not do for one of these, however humble, you did not do for me."

And they will go away to eternal punishment, but the righteous will enter eternal life.'

— MATTHEW 25

'For when I was hungry, you gave me food; when thirsty, you gave me drink; . . .'

— MATTHEW 25

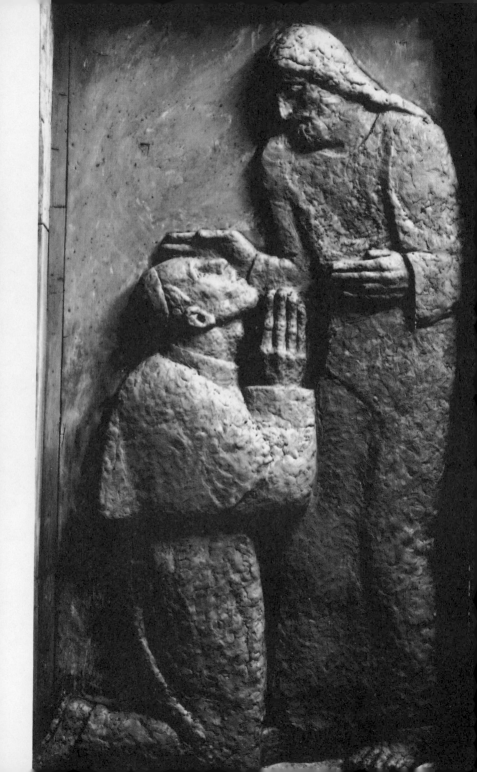

'The thief comes only to steal, to kill, to destroy; I have come that men may have life, and may have it in all its fullness.

I am *the good shepherd*; the good shepherd lays down his life for the sheep.

The hireling, when he sees the wolf coming, abandons the sheep and runs away, because he is no shepherd and the sheep are not his.

Then the wolf harries the flock and scatters the sheep.

The man runs away because he is a hireling and cares nothing for the sheep.

'I am the good shepherd; I know my own sheep and my sheep know me — as the Father knows me and I know the Father — and I lay down my life for the sheep.'

— JOHN 10

"I am the good shepherd . . .'
(Jesus appearing to Cardinal Stepinac)

— JOHN 10

When it was Simon Peter's turn, Peter said to him, 'You, Lord, washing my feet?'

Jesus replied, 'You do not understand now what I am doing, but one day you will.'

Peter said, 'I will never let you wash my feet.'

'If I do not wash you,' Jesus replied, 'you are not in fellowship with me.'

'Then, Lord,' said Simon Peter, *'not my feet only; wash my hands and head as well!'*

.

After washing their feet and taking his garments again, he sat down.

'Do you understand what I have done for you?' he asked. . . .

'I have set you an example: you are to do as I have done for you.

In very truth I tell you, a servant is not greater than his master, nor a messenger than the one who sent him.

If you know this, happy are you if you act upon it.'

— JOHN 13

And here is another parable that [Jesus] told.

It was aimed at those who were sure of their own goodness and looked down on everyone else.

'Two men went up to the temple to pray, one a Pharisee and the other a tax-gatherer.

The Pharisee stood up and prayed thus: "I thank thee, O God, that I am not like the rest of men, greedy, dishonest, adulterous; or, for that matter, like this tax-gatherer.

I fast twice a week; I pay tithes on all that I get."

But the other kept his distance and would not even raise his eyes to heaven, but beat upon his breast, saying, "O God, have mercy on me, *sinner that I am.*"

It was this man, I tell you, and not the other, who went home acquitted of his sins.

For everyone who exalts himself will be humbled; and whoever humbles himself will be exalted.'

— LUKE 18

So Mary [of Bethany] came to the place where Jesus was.

As soon as she caught sight of him she fell at his feet and said, 'O sir, if you had only been here my brother [Lazarus] would not have died.'

When Jesus saw her weeping and the Jews her companions weeping, he sighed heavily and was deeply moved.

'Where have you laid him?' he asked.

They replied, 'Come and see, sir.'

Jesus wept.

The Jews said, 'How dearly he must have loved him!'. . .

Jesus again sighed deeply; then he went over to the tomb.

It was a cave, with a stone placed against it.

Jesus said, 'Take away the stone.'

Martha, the dead man's sister, said to him, 'Sir, by now there will be a stench; he has been there four days.'

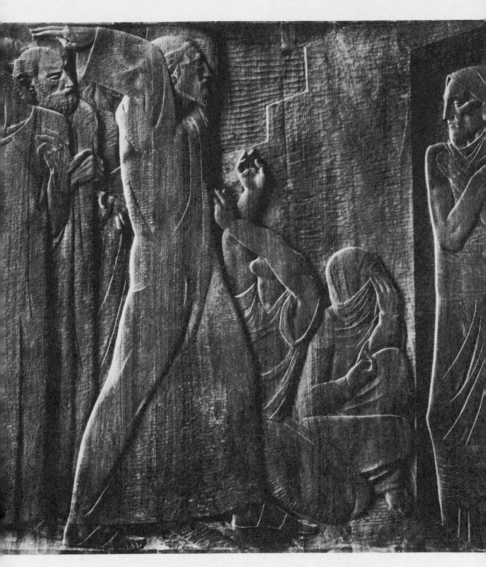

*Jesus again sighed deeply; then he went over
to the tomb. It was a cave, with a stone placed
against it. Jesus said, 'Take away the stone.'*

— JOHN 11

Jesus said, 'Did I not tell you that if you have faith you will see the glory of God?' So they removed the stone.

Then Jesus looked upwards and said, 'Father, I thank thee; thou hast heard me. I knew already that thou always hearest me, but I spoke for the sake of the people standing round, that they might believe that thou didst send me.'

Then he raised his voice in a great cry: 'Lazarus, come forth.' The dead man came out, his hands and feet swathed in linen bands, his face wrapped in a cloth. Jesus said, 'Loose him; let him go.'

Now many of the Jews who had come to visit Mary and had seen what Jesus did, put their faith in him. But some of them went off to the Pharisees and reported what he had done.

— JOHN 11

Six days before the Passover festival Jesus came to Bethany, where Lazarus lived whom he had raised from the dead.

There a supper was given in his honour, at which Martha served, and Lazarus sat among the guests with Jesus.

Then Mary brought a pound of very costly perfume, pure oil of nard, and anointed the feet of Jesus and wiped them with her hair, till the house was filled with the fragrance.

At this, Judas Iscariot, a disciple of his — the one who was to betray him — said, 'Why was this perfume not sold for thirty pounds and given to the poor?'

He said this, not out of any care for the poor, but because he was a thief; he used to pilfer the money put into the common purse, which was in his charge.

'Leave her alone', said Jesus.

'Let her keep it till the day when she prepares for my burial; for you have the poor among you always, but *you will not always have me.*'

— John 12

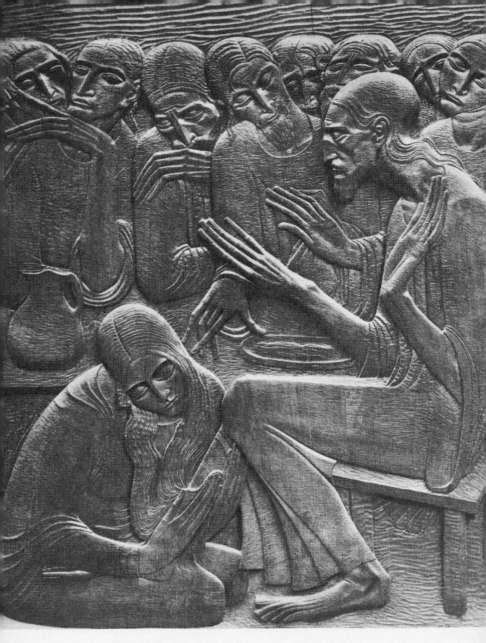

*Then Mary brought a pound of very costly perfume
. . . and anointed the feet of Jesus . . .*

— JOHN 12

Then one of the lawyers, who had been listening to these discussions and had noted how well he answered, came forward and asked him, 'Which commandment is first of all?'

Jesus answered, 'The first is, "Hear, O Israel: the Lord our God is the only Lord; love the Lord your God with all your heart, with all your soul, and with all your strength."

The second is this: "Love your neighbour as yourself."

There is no other commandment greater than these.'

The lawyer said to him, 'Well said, Master.

You are right in saying that God is one and beside him there is no other.

And to *love him with all your heart,* all your understanding, and all your strength, and to love your neighbour as yourself — that is far more than any burnt offerings or sacrifices.'

When Jesus saw how sensibly he answered, he said to him, 'You are not far from the kingdom of God.'

— Mark 12

People were now gathering in large numbers, and as they made their way to him from one town after another, [Jesus] said in a parable: '*A sower went out to sow his seed.*

And as he sowed, some seed fell along the footpath, where it was trampled on, and the birds ate it up.

Some seed fell on rock and, after coming up, withered for lack of moisture.

Some seed fell in among thistles, and the thistles grew up with it and choked it.

And some of the seed fell into good soil, and grew, and yielded a hundredfold.'

As he said this he called out, 'If you have ears to hear, then hear.'

His disciples asked him what this parable meant, and he said, ...

'This is what the parable means.

The seed is the word of God.

Those along the footpath are the men who hear it, and then the devil comes and carries off the word from their hearts for fear they should believe and be saved.

The seed sown on rock stands for those who receive the word with joy when they hear it, but have no root; they are believers for a while, but in the time of testing they desert.

That which fell among thistles represents those who hear, but their further growth is choked by cares and wealth and the pleasures of life, and they bring nothing to maturity.

But the seed in good soil represents those who bring a good and honest heart to the hearing of the word, hold it fast, and by their perseverance yield a harvest.'

—LUKE 8

'Set your troubled hearts at rest.

Trust in God always; trust also in me.

There are many dwelling-places in my Father's house; if it were not so I should have told you; for I am going there on purpose to prepare a place for you.

And if I go and prepare a place for you, I shall come again and receive you to myself, so that where I am you may be also; and my way there is known to you.'

Thomas said, 'Lord, we do not know where you are going, so how can we know the way?'

Jesus replied, 'I am the way; I am the truth and I am life; no one comes to the Father except by me.

'If you knew me you would know my Father too.

From now on you do know him; you have seen him.'

Philip said to him, 'Lord, show us the Father and we ask no more.'

Jesus answered, 'Have I been all this time with you, Philip, and you still do not know me?

Anyone who has seen me has seen the Father.

Then how can you say, "Show us the Father"?

Do you not believe that I am in the Father, and the Father in me?

I am not myself the source of the words I speak to you: it is the Father who dwells in me doing his own work.

Believe me when I say that I am in the Father and the Father in me; or else accept the evidence of the deeds themselves.

In truth, in very truth I tell you, he who has faith in me will do what I am doing; and he will do greater things still because I am going to the Father.

Indeed anything you ask in my name I will do, so that the Father may be glorified in the Son.

If you ask anything in my name I will do it.'

— JOHN 14

Jesus replied, 'Anyone who loves me will heed what I say; then my Father will love him, and we will come to him and make our dwelling with him; but he who does not love me does not heed what I say.

And the word you hear is not mine: it is the word of the Father who sent me.

I have told you all this while I am still here with you; but your Advocate, the Holy Spirit whom the Father will send in my name, will teach you everything, and will call to mind all that I have told you.

'Peace is my parting gift to you, my own peace, such as the world cannot give.

Set your troubled hearts at rest, and banish your fears. You heard me say, "I am going away, and coming back to you."

If you loved me you would have been glad to hear that I was going to the Father; for the Father is greater than I.

I have told you now, beforehand, so that when it happens you may have faith.

.

'I have spoken thus to you, so that my joy may be in you, and your joy complete.

This is my commandment: *love one another*, as I have loved you.

There is no greater love than this, that a man should lay down his life for his friends.

You are my friends, if you do what I command you.

I call you servants no longer; a servant does not know what his master is about.

I have called you friends, because I have disclosed to you everything that I heard from my Father.

You did not choose me: I chose you.

I appointed you to go on and bear fruit, fruit that shall last; so that the Father may give you all that you ask in my name.

This is my commandment to you: love one another.'

— John 14, 15

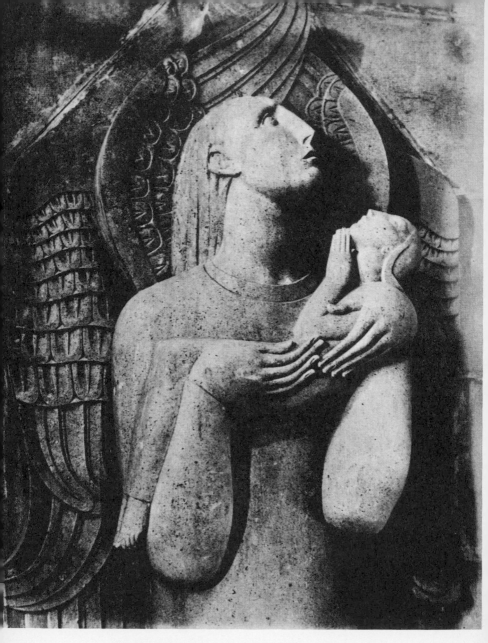

'Peace is my parting gift to you,
my own peace, such as the world cannot give.'

— JOHN 14

After these words Jesus looked up to heaven and said:

'Father, the hour has come.

Glorify thy Son, that the Son may glorify thee.

.

'I pray for them; I am not praying for the world but for those whom thou hast given me, because they belong to thee.

All that is mine is thine, and what is thine is mine; and through them has my glory shone.

'I am to stay no longer in the world, but they are still in the world, and I am on my way to thee.

Holy Father, protect by the power of thy name those whom thou hast given me, that they may be one, as we are one.

When I was with them, I protected by the power of thy name those whom thou hast given me, and kept them safe.

Not one of them is lost except the man who must be lost, for Scripture has to be fulfilled.

.

'I have glorified thee on earth by completing the work which thou gavest me to do; and now, Father, glorify me in thy own presence with the glory which I had with thee before the world began.

'I have made thy name known to the men whom thou didst give me out of the world.

They were thine, thou gavest them to me, and they have obeyed thy command.

Now they know that all thy gifts have come to me from thee; for I have taught them all that I learned from thee, and they have received it; they know with certainty that I came from thee; they have had faith to believe that thou didst send me.

.

'And now I am coming to thee; but while I am still in the world I speak these words, so that they may have my joy within them in full measure.

I have delivered thy word to them, and the world hates them because they are strangers in the world, as I am.

I pray thee, not to take them out of the world, but to keep them from the evil one.

They are strangers in the world, as I am.

Consecrate them by the truth; thy word is truth.

As thou hast sent me into the world, I have sent them into the world, and for their sake I now consecrate myself, that they too may be consecrated by the truth.

.

'But it is not for these alone that I pray, but for those also who through their words put their faith in me; may they all be one: as thou, Father, art in me, and I in thee, so also may they be in us, that the world may believe that thou didst send me.

The glory which thou gavest me I have given to them, that they may be one, as we are one; I in them and thou in me, may they be perfectly one.

Then the world will learn that thou didst send me, *that thou didst love them* as thou didst me.

'Father, I desire that these men, who are thy gift to me, may be with me where I am, so that they may look upon my

glory, which thou hast given me because thou didst love me before the world began.

O righteous Father; although the world does not know thee, I know thee, and these men know that thou didst send me.

I made thy name known to them, and will make it known, so that the love thou hadst for me may be in them, and I may be in them.'

— JOHN 17

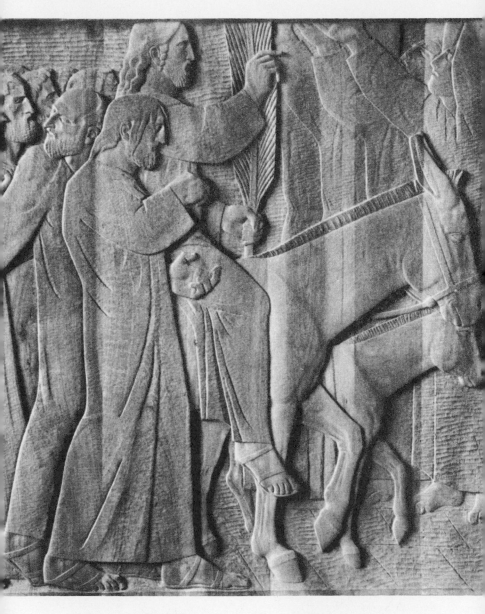

'*I have glorified thee on earth by completing
the work which thou gavest me to do . . .*'

— John 17



On the first day of Unleavened Bread the disciples came to ask Jesus, 'Where would you like us to prepare for your Passover supper?'

He answered, 'Go to a certain man in the city, and tell him, "The Master says, *My appointed time is near;* I am to keep Passover with my disciples at your house.'"'

The disciples did as Jesus directed them and prepared for Passover.

.

During supper Jesus took bread, and having said the blessing he broke it and gave it to the disciples with the words: 'Take this and eat; this is my body.'

Then he took a cup, and having offered thanks to God he gave it to them with the words: 'Drink from it, all of you.

For this is my blood, the blood of the covenant, shed for many for the forgiveness of sins.

I tell you, never again shall I drink from the fruit of the vine until that day when I drink it new with you in the kingdom of my Father.'

After singing the Passover Hymn, they went out to the Mount of Olives.

Then Jesus said to them, 'Tonight you will all fall from your faith on my account; for it stands written: "I will strike the shepherd down and the sheep of his flock will be scattered."

But after I am raised again, I will go on before you into Galilee.'

— MATTHEW 26

During supper Jesus took bread,
and having said the blessing
he broke it and gave it to the disciples
with the words: 'Take this and eat;
this is my body.' (overleaf)

— MATTHEW 26

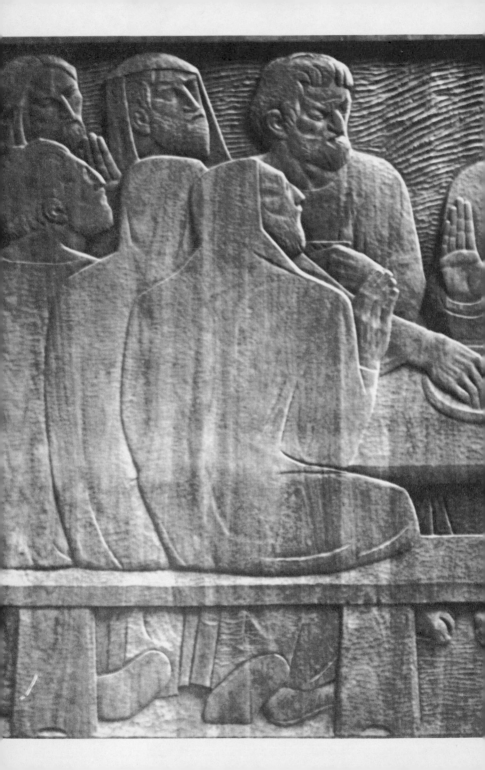

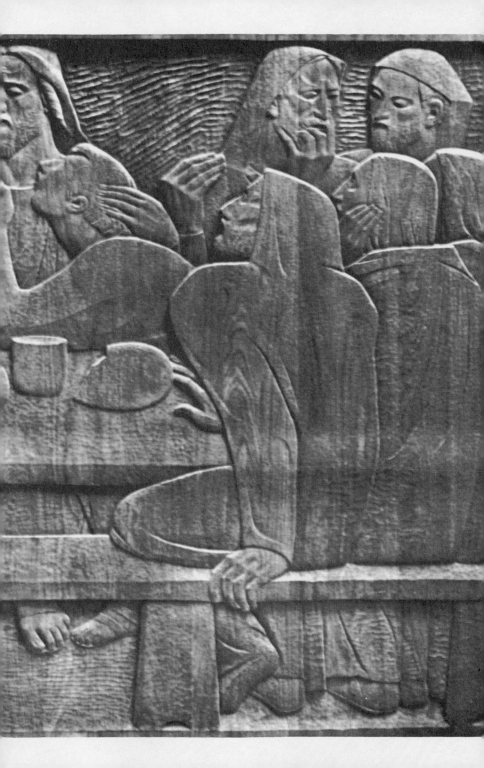

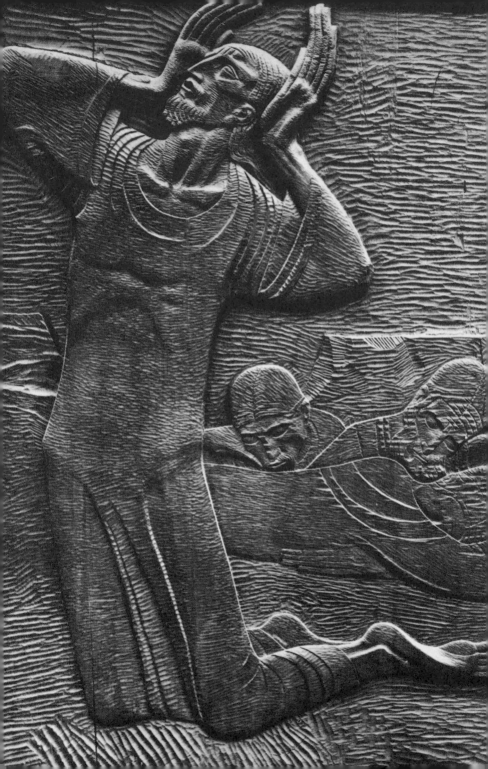

Jesus then came with his disciples to a place called Gethsemane.

He said to them, 'Sit here while I go over there to pray.'

He took with him Peter and the two sons of Zebedee.

Anguish and dismay came over him, and he said to them, 'My heart is ready to break with grief.

Stop here, and stay awake with me.'

He went on a little, fell on his face in prayer, and said, 'My Father, if it is possible, *let this cup pass me by.*

Yet not as I will, but as thou wilt.'

.

He went away a second time, and prayed: 'My Father, if it is not possible for this cup to pass me by without my drinking it, thy will be done.'

He came again and found them asleep, for their eyes were heavy.

. . . 'My Father, if it is possible,
let this cup pass me by.'

— Matthew 26

So he left them and went away again; and he prayed the third time, using the same words as before.

Then he came to the disciples and said to them, 'Still sleeping?
Still taking your ease?
The hour has come!
The Son of Man is betrayed to sinful men.
Up, let us go forward; the traitor is upon us.'

While he was still speaking, Judas, one of the Twelve, appeared; with him was a great crowd armed with swords and cudgels, sent by the chief priests and the elders of the nation.

The traitor gave them this sign: 'The one I kiss is your man; seize him'; and stepping forward at once, he said, 'Hail, Rabbi!', and kissed him.

Jesus replied, 'Friend, do what you are here to do.'

They then came forward, seized Jesus, and held him fast.

At that moment one of those with Jesus reached for his sword and drew it, and he struck at the High Priest's servant and cut off his ear.

But Jesus said to him, 'Put up your sword.

All who take the sword die by the sword.

Do you suppose that I cannot appeal to my Father, who would at once send to my aid more than twelve legions of angels?'

— MATTHEW 26

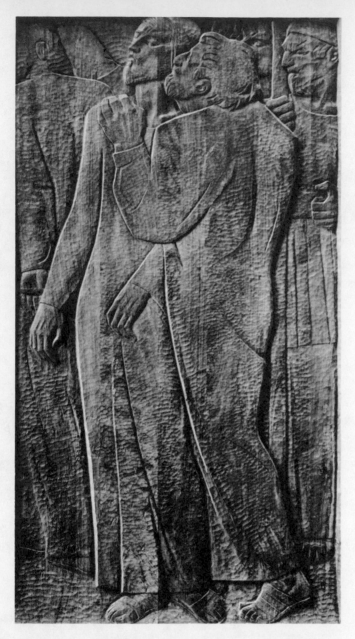

(Judas) gave them this sign: 'The one I kiss is your man; seize him:' and stepping forward at once, he said, 'Hail Rabbi!', and kissed him.

— Matthew 26

The chief priests and the whole Council tried to find some allegation against Jesus on which a death-sentence could be based; but they failed to find one, though many came forward with false evidence.

Finally two men alleged that he had said, 'I can pull down the temple of God, and rebuild it in three days.'

At this the High Priest rose and said to him, 'Have you no answer to the charge that these witnesses bring against you?'

But Jesus kept silence.

The High Priest then said, 'By the living God I charge you to tell us: Are you the Messiah, the Son of God?'

Jesus replied, 'The words are yours.

But I tell you this: from now on, you will see the Son of Man seated at the right hand of God and coming on the clouds of heaven.'

At these words the High Priest tore his robes and exclaimed, 'Blasphemy! . . .

What is your opinion?'

'He is guilty', they answered; 'he should die.'

— MATTHEW 26

When morning came, the chief priests and the elders of the nation met in conference to plan the death of Jesus.

They then put him in chains and led him away, to hand him over to Pilate, the Roman Governor.

.

Jesus was now brought before the Governor; and as he stood there the Governor asked him, 'Are you the king of the Jews?'

'The words are yours', said Jesus; and to the charges laid against him by the chief priests and elders he made no reply.

.

Pilate could see that nothing was being gained, and a riot was starting; so he took water and washed his hands in full view of the people, saying, 'My hands are clean of this man's blood; see to that yourselves.'

And with one voice the people cried, 'His blood be on us, and on our children.'...

Pilate's soldiers then took Jesus into the Governor's headquarters, where they collected the whole company round him.

They stripped him and dressed him in a scarlet mantle; and plaiting a crown of thorns they placed it on his head, with a cane in his right hand.

Falling on their knees before him they jeered at him: 'Hail, King of the Jews!'

They spat on him, and used the cane to beat him about the head.

When they had finished their mockery, they took off the mantle and dressed him in his own clothes.

.

So they came to a place called Golgotha (which means 'Place of a skull') and there he was offered a draught of wine mixed with gall; but when he had tasted it he would not drink.

After fastening him to the cross they divided his clothes among them by casting lots, and then sat down there to keep watch.

Over his head was placed the inscription giving the charge: 'This is Jesus the king of the Jews.'

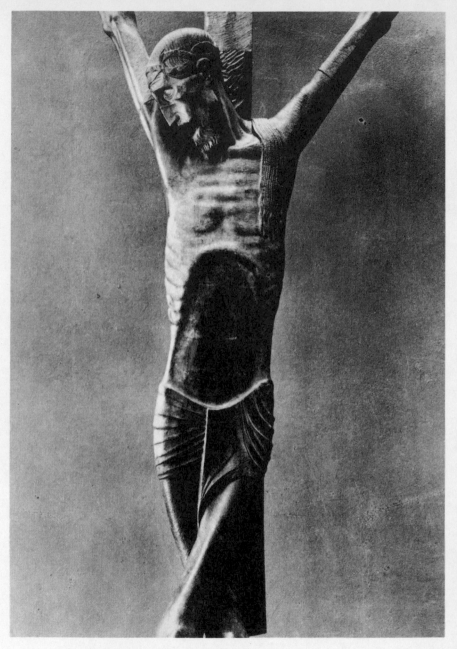

After fastening him to the cross
they divided his clothes among them
by casting lots, and then sat down there
to keep watch.

— MATTHEW 27

Two bandits were crucified with him, one on his right and the other on his left.

The passers-by hurled abuse at him: they wagged their heads and cried, 'You would pull the temple down, would you, and build it in three days?

Come down from the cross and save yourself, if you are indeed the Son of God.'

So too the chief priests with the lawyers and elders mocked at him: 'He saved others,' they said, 'but he cannot save himself.

King of Israel, indeed!

Let him come down now from the cross, and then we will believe him.

Did he trust in God?

Let God rescue him, if he wants him — for he said he was God's Son.'

Even the bandits who were crucified with him taunted him in the same way.

From midday a darkness fell over the whole land, which lasted, until three in the afternoon; and about three Jesus cried

aloud, 'Eli, Eli, lema sabachthani?', which means, 'My God, my God, *why hast thou forsaken me?'* . . .

. . .And when the centurion and his men who were keeping watch over Jesus saw the earthquake and all that was happening, they were filled with awe, and they said, 'Truly this man was a son of God.'

.

When evening fell, there came a man of Arimathaea, Joseph by name, who was a *man of means,* and had himself become a disciple of Jesus.

He approached Pilate, and asked for the body of Jesus; and Pilate gave orders that he should have it.

Joseph took the body, wrapped it in a clean linen sheet, and laid it in his own unused tomb, which he had cut out of rock; he then rolled a large stone against the entrance, and went away.

Mary of Magdala was there, and the other Mary, sitting opposite the grave.

Next day, the morning after that Friday, the chief priests and the Pharisees came in a body to Pilate.

127

'Your Excellency', they said, 'we recall how that impostor said while he was still alive, "I am to be raised again after three days."

So will you give orders for the grave to be made secure until the third day?

Otherwise his disciples may come, steal the body, and then tell the people that he has been raised from the dead; and the final deception will be worse than the first.'

'You may have your guard', said Pilate; 'go and make it secure as best you can.'

So they went and made the grave secure; they sealed the stone, and left the guard in charge.

— MATTHEW 27

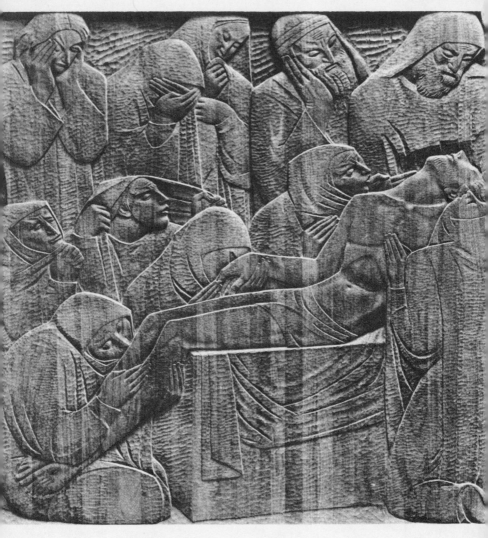

*Joseph took the body, wrapped it in a clean
linen sheet, and laid it in his own unused tomb,
which he had cut out of the rock; ...*

— MATTHEW 27

Early on the Sunday morning, while it was still dark, Mary of Magdala came to the tomb.

She saw that the stone had been moved away from the entrance, and ran to Simon Peter and the other disciple, the one whom Jesus loved.

'They have taken the Lord out of his tomb', she cried, 'and we do not know where they have laid him.'

So Peter and the other set out and made their way to the tomb.

They were running side by side, but the other disciple outran Peter and reached the tomb first.

He peered in and saw the linen wrappings lying there, but did not enter.

Then Simon Peter came up, following him, and he went into the tomb.

He saw the linen wrappings lying, and the napkin which had been over his head, not lying with the wrappings but rolled together in a place by itself.

— JOHN 20

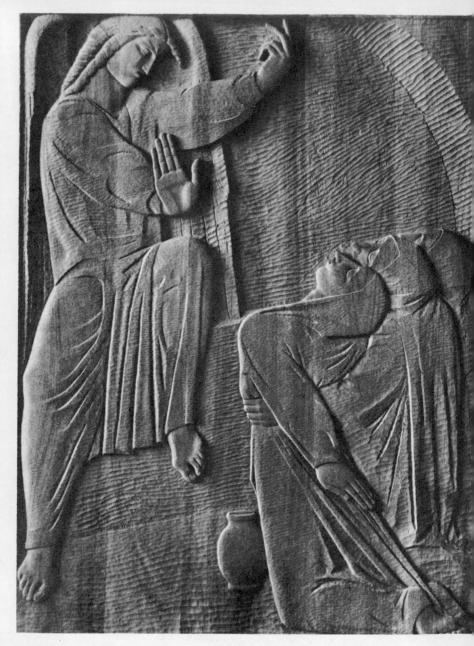

. . . She saw two angels in white sitting there
. . . where the body of Jesus had lain.

— JOHN 20

So the disciples went home again; but Mary stood at the tomb outside, weeping.

As she wept, she peered into the tomb; and she saw two angels in white sitting there, one at the head, and one at the feet, where the body of Jesus had lain.

They said to her, 'Why are you weeping?'

She answered, 'They have taken my Lord away, and I do not know where they have laid him.'

With these words she turned round and saw Jesus standing there, but did not recognize him.

Jesus said to her, *'Why are you weeping?*

Who is it you are looking for?'

.

Jesus said, 'Mary!'

She turned to him and said, 'Rabbuni!' (which is Hebrew for 'My Master').

Jesus said, 'Do not cling to me, for I have not yet ascended to the Father. . . .'

Mary of Magdala went to the disciples with her news: 'I have seen the Lord! . . .'

— JOHN 20

Late that Sunday evening, when the disciples were together behind locked doors, for fear of the Jews, Jesus came and stood among them.

'*Peace be with you!*' he said, and then showed them his hands and his side.

So when the disciples saw the Lord, they were filled with joy.

Jesus repeated, 'Peace be with you!', and said, 'As the Father sent me, so I send you.'

Then he breathed on them, saying, 'Receive the Holy Spirit!

If you forgive any man's sins, they stand forgiven; if you pronounce them unforgiven, unforgiven they remain.'

.

There were indeed many other signs that Jesus performed in the presence of his disciples, which are not recorded in this book.

Those here written have been recorded in order that you may hold the faith that Jesus is the Christ, the Son of God, and that through this faith you may possess life by his name.

— JOHN 20

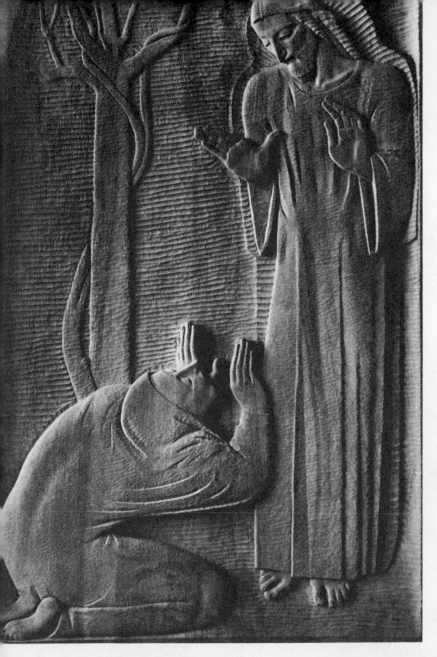

'Peace be with you!'

— JOHN 20

Some time later, Jesus showed himself to his disciples once again, by the Sea of Tiberias; and in this way.

Simon Peter and Thomas 'the Twin' were together with Nathanael of Cana-in-Galilee.

The sons of Zebedee and two other disciples were also there.

Simon Peter said, 'I am going out fishing.'

'We will go with you', said the others.

So they started and got into the boat.

But that night they caught nothing.

Morning came, and there stood Jesus on the beach, but the disciples did not know that it was Jesus.

He called out to them, 'Friends, have you caught anything?'

They answered 'No.'

He said, 'Shoot the net to starboard, and you will make a catch.'

They did so, and found they could not haul the net aboard, there were so many fish in it.

Then the disciple whom Jesus loved said to Peter, 'It is the Lord!'

When Simon Peter heard that, he wrapped his coat about him (for he had stripped) and plunged into the sea.

The rest of them came on in the boat, towing the net full of fish; for they were not far from land, only about a hundred yards.

When they came ashore, they saw a charcoal fire there, with fish laid on it, and some bread.

Jesus said, 'Bring some of your catch.'

Simon Peter went aboard and dragged the net to land, full of big fish, a hundred and fifty-three of them; and yet, many as they were, the net was not torn.

Jesus said, 'Come and have breakfast.'

None of the disciples dared to ask 'Who are you?'

They knew it was the Lord.

Jesus now came up, took the bread, and gave it to them, and the fish in the same way.

This makes the third time that Jesus appeared to his disciples after his resurrection from the dead.

— JOHN 21

After breakfast, Jesus said to Simon Peter, 'Simon son of John, do you love me more than all else?'

'Yes, Lord,' he answered, 'you know that I love you.'

'Then feed my lambs', he said.

A second time he asked, 'Simon son of John, do you love me?'

'Yes, Lord, you know I love you.'

'Then tend my sheep.'

A third time he said, 'Simon son of John, do you love me?'

Peter was hurt that he asked him a third time, 'Do you love me?'

'Lord,' he said, 'you know everything; *you know I love you.*'

Jesus said, 'Feed my sheep.'

.

Peter looked round, and saw the disciple whom Jesus loved following — the one who at supper had leaned back close to him to ask the question, 'Lord, who is it that will betray you?'

.

138

It is this same disciple who attests what has here been written.

It is in fact he who wrote it, and we know that his testimony is true.

There is much else that Jesus did.

If it were all to be recorded in detail, I suppose the whole world could not hold the books that would be written.

— JOHN 21

It is in fact (John the Evangelist) who wrote it, and we know that his testimony is true.

— JOHN 21

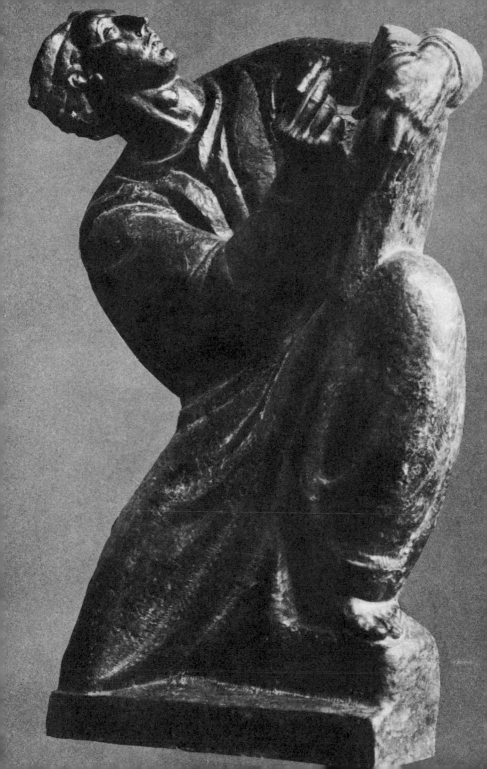

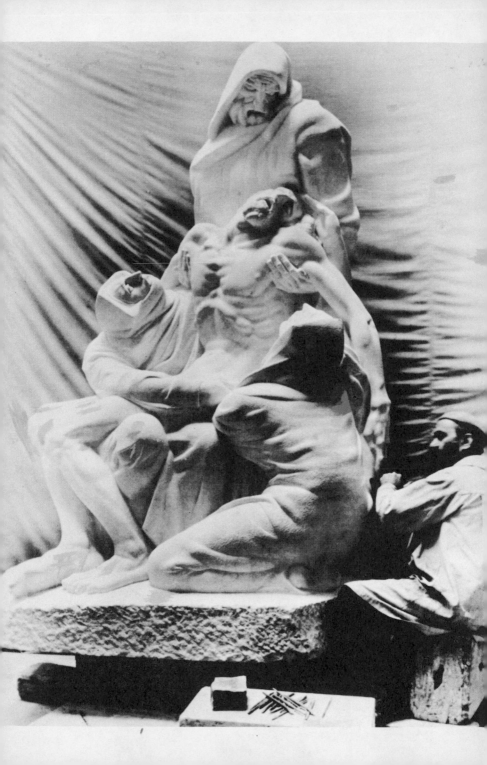

IVAN MEŠTROVIĆ (1883-1962)

The master French sculptor Auguste Rodin said that "Meštrović was the greatest phenomenon among the sculptors" of his time. Great artists are few in any age. Even rarer is the great artist of the twentieth century who considers art to be a medium for the expression of ideas and ideals rather than the idea itself. But such a man was Ivan Meštrović. Neither impressionist nor expressionist and affiliated with no stylistic groups, his art was basically an attempt to express the essence of two ideas: democratic freedom and Christian truth. And for Meštrović, the one depended upon the other: The democratic ideal is rooted in Christian principles.

Meštrović spoke of this in 1954 when he received the Christian Culture Award Medal:

> Christian civilization, in our days, finds itself locked in mortal struggle with the forces of secularism in varying forms and degrees. Too many people still fail to realize that Christianity, by waging the fight for its principles, defends also the foundations of the democratic way of life: For the concept of the dignity of each man and the equality of all men stands and falls with the Christian view that man is created in the image of God. Thus the Church is in the front lines of the battle against the onslaughts of human freedom.

"Perplexed and confused" by the "destructiveness of all human values" during World War II, he said,

> I took the book which in my childhood I had read without a great deal of understanding; only the memory of its poetic beauty had still lingered in my mind. But now I understood it: I knew then that this book contained not only unmatched beauty but also the profoundest wisdom. The book was the New Testament.

> Inspired by the great drama of the Son of God becoming Flesh, I started to work on the themes taken from the life of Jesus of Nazareth.

It is no accident that Meštrović's work over the decades was devoted with an incredible singlemindedness to the expression of the "dignity of each man" and the "great drama of the Son of God becoming Flesh" and that his work is filled with a peasant strength. For he was the son of peasants. Born in 1883 in the tiny village of Vrpolje in Croatia in the northern part of what is now Yugoslavia, he was the eldest of ten children. His family's home village was in an extremely poor section of forbidding Dalmatian mountain country. His father was a farmer and mason, a builder of houses. At an early age Meštrović became interested in the functions of the chisel and mallet usesd for the simple decoration of the peasants' stone houses. His father was also the only literate man in their village and he taught his son to read using the Bible, calendars and a few books of epic poetry and ballads of the country.

At the age of fifteen, Meštrović was apprenticed to a stonecutter and he shortly thereafter carved statues which attracted the attention of a Viennese mineowner who sent the young sculptor to the Vienna Academy of Fine Arts. He left the Academy in 1904 because he found it difficult to adjust to the conventional modes of expression, and went to Paris where he met Rodin.

Because Meštrović was politically suspect, he was forced
to flee to Rome when war broke out in 1914 between Serbia
and Austria-Hungary. After World War I, he returned to
his country and concentrated on architectural projects such
as churches and memorial chapels and on crystallizing his di-
verse projects in the form of mature and permanent
monuments.

After the outbreak of World War II, he was imprisoned
by the Gestapo for a few months before he was allowed to
leave his country. Working in Rome again during the war,
he found release in sculpturing religious subjects.

Meštrović's political affiliations made it impossible for him
to return after the war to a communist-dominated Croatia
(now part of Yugoslavia) and he accepted a professorship at
Syracuse University in the United States. In 1954, he sent
to Croatia — to the countrymen he was never to see again —
a gift of thirty wooden reliefs depicting the life of Christ,
and said: "No matter how far fate has blown the frail tree of
my life across foreign lands, it roots have always sucked
nourishment from that little barren clod of soil from which
it sprung."

The sculptor spent his last years at Notre Dame University,
where he died in 1962. His wife still resides in South Bend,
Indiana.

LIST OF ILLUSTRATIONS

Page	Picture
2	MADONNA WITH CHILD. Diorite stone. Life size. 1928. Property of artist's family.
9	THE ANNUNCIATION. Panel in wood. Life size. Designed for Meštrović Family Chapel, Split, Yugoslavia.
14	THE NATIVITY. Panel in wood. Life size. Designed for Meštrović Family Chapel, Split, Yugoslavia.
16	THE PRESENTATION. Panel in wood. Life size. Designed for the Meštrović Family Chapel, Split, Yugoslavia.
19	JESUS AMONGST WISE MEN. Wood. Life size. 1940. Property of the artist's family.
23	SERMON FROM THE MOUNT. Wood relief. Life size. 1927. Property of the artist's family.
36	CHRIST AND THE WOMAN OF SAMARIA. Wood relief. Life size. 1927. Property of the artist's family.
42	JESUS AND MAGDALEN. Wood. Life size. 1943. Property of the artist's family.
47	DETAIL OF ANGEL WITH SOUL. Stone. Over life size. 1922. Račić Family Mausoleum, Dalmatia, Yugoslavia.
52	MY MOTHER. Marble. Life size. 1907. State Museum, Belgrade, Yugoslavia.
62	WOMAN WITH A HARP. Marble. Over life size. 1930. Property of the artist's family.
72	WIDOWS. Marble. Over life size. 1907. State Museum, Belgrade, Yugoslavia.
75	MADONNA WITH CHILDREN. Bronze. Life size. 1932. Property of the artist's family.
78	THE TEMPTATION. Wood relief. Life size. 1917. Property of the artist's family.
84	JUDGEMENT OF THE SINNER. Wood. Life size. 1943. Property of the artist's family.
88	NURSE FEEDING SICK SOLDIER. Marble relief. Life size. 1953. Bellevue School of Nursing, New York. Photography/Bruce Harlan, Notre Dame, Indiana.
90	CHRIST AND CARDINAL STEPINAC. Marble. Life size. 1961. Cathedral of the Assumption, Zagreb, Yugoslavia. Photography/Bruce Harlan, Notre Dame, Indiana.
95	RAISING OF LAZARUS. Wood relief. Life size. 1940. Destroyed during World War II.
98	JESUS AND MAGDALEN. Wood. Life size. 1917-18. Croatian Museum, Zagreb, Yugoslavia.
106	DETAIL OF ANGEL WITH SOUL. Stone. Over life size. 1922. Račić Family Mausoleum, Dalmatia, Yugoslavia.
111	ENTRANCE INTO JERUSALEM. Wood relief. Life size. 1943. Property of the artist's family.
114-115	THE LAST SUPPER. Panel in wood. Life size. Designed for Meštrović Family Chapel, Split, Yugoslavia.
116	IN GETHSEMANE. Wood. Life size. 1917. Property of the artist's family.
120	THE JUDAS KISS. Panel in wood. Life size. Designed for Meštrović Family Chapel, Split, Yugoslavia.
124	DETAIL OF CHRIST ON THE CROSS. Wood. Over life size. 1917. Property of the artist's family.
128	THE DEPOSITION. Wood. Life size. 1917. Property of the artist's family.
130	HE HAS ARISEN. Wood. Life size. 1943. Property of the artist's family.
133	DO NOT TOUCH ME. Wood. Life size. 1943. Property of the artist's family.
139	JOHN THE EVANGELIST. Bronze. Over life size. 1929. Property of the artist's family.
140	Artist at work on PIETÀ. Marble. Over life size. 1942, 1946. Property of the artist's family.